Soft Stone Carving

Soft Stone Carving

C. A. I. Ritchie

A Scopas Handbook

Academy Editions · London
St. Martin's Press · New York

Scopas Handbooks

Series editor:
Christine Bernard

First published in Great Britain
in 1973 by Academy Editions
7 Holland Street London W8

Copyright © 1973 Academy Editions;
all rights reserved.

First published in the U.S.A.
in 1973 by St. Martin's Press Inc.,
175 Fifth Avenue, New York N.Y. 10010

Library of Congress
catalog card number
73–77763

Printed and bound in Great Britain
at The Pitman Press, Bath

SBN hardback 85670 016 9
SBN paperback 85670 021 5

Contents

For Bernadine Bailey

Preface

This book has been written to introduce sculptors or aspirant sculptors of all ages to a wide group of materials which do not normally form the raw material of a sculptor's *atelier* nowadays but which have all been used in the past to produce sculptures of high quality.

It is hoped that anyone, trained or not, will be able to tackle at least some of the projects outlined in this book. Some of the substances described are so soft that they can be carved with a plastic knife; they would therefore constitute suitable carving materials for young children who cannot be trusted with sharp or heavy tools, or the invalid or handicapped. Other materials are widely distributed in Britain, and were used for sculptures in the past. Some of them are still being used for carving, others have suffered from an undeserved neglect. I hope that what I have written will be a reminder that there is much good sculptural material to be picked up literally right on our doorsteps. All the materials I describe are easy to carve. None of them require special equipment beyond a few basic tools. Some of them can be carved without resorting to a special studio. Leonardo Da Vinci used to say that it was better for a gentleman to be an artist than a sculptor, as sculpture was too hard work. I feel he might have felt differently if he had worked in some of the stones which I describe here. I would not for a moment suggest that there is any royal road to sculpture, but there are one or two bridle paths which are easier going than the hard high road; this is one of them.

Sculptors and critics alike sometimes tend to treat sculpture as if it were inseparably wedded to stone-moving equipment, powered machinery, floors littered with stone chippings, a perpetual atmosphere of dust, all leading up to the development of the completed sculpture as part of an architectural facade. Good sculpture can be held in the hand as well as viewed as part of a building, and if prices paid are any indication of the value set on sculpture, the Greeks and Romans were as well satisfied with a pocket-sized carving in amber as with a plinth statue or a frieze.

7

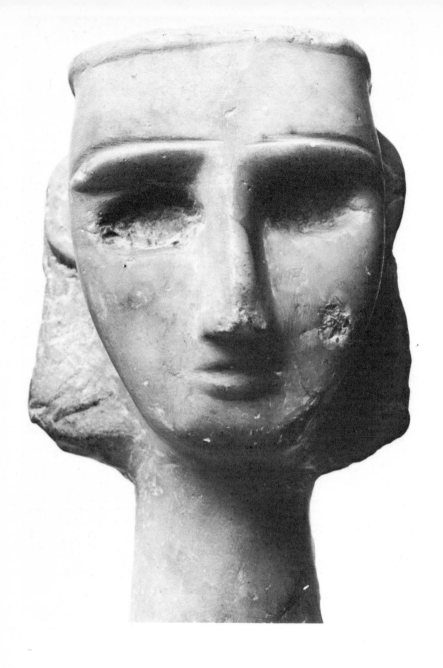

1. Votive head in alabaster, formerly with inlaid eyes, South Arabian, late first millenium BC or early first millenium AD. *British Museum, London*

Historical Background to Soft Stone Carving

Some of the materials described in this book are the very oldest of all sculptor's stones. Two kinds of stone were worked under the name of Alabaster in the ancient world, and the one most commonly called this was onyx marble. Ancient man came in contact with onyx marble, or *ancient alabaster* at a very early date because it hung from the walls and roofs of the caves in which he lived, and after death covered his remains. When man first began making engravings and shallow carvings it was naturally to the alabaster covered walls and floors of his home that he would turn. Hundreds of years later the Chinese were still doing the same thing. In the sacred Buddhist caverns of China statues of gods, carved from upstanding stalagmites can still be seen.

When man emerged from the caves he took ancient alabaster with him. It became one of the favoured materials of ancient Egypt, where it was used for the most sacred purpose any stone could serve—to house the entrails removed from the mummy in Canopic jars. It was also made into great stone coffins or sarcophagi, such as that which belonged to Seti I (died 1304 BC), which is preserved in Sir John Soane's museum in London. The tomb of the boy pharaoh Tutankamen (1361–1352 BC) contained some of the finest alabaster carvings ever made, including ointment jars, toilet bottles and wonderful lamps, made from two pieces of alabaster fitted together so that they made a double shade. Inside the inner cavity of the double shade there was painted a design which was invisible when the lamp was not burning. Once it was lit however the design not merely came into view through the transparent alabaster wall of the shade but even threw coloured shadows on the wall, something which must have amazed anyone who did not know the secret of the lamp.

In ancient Sumer, in Mesopotamia, alabaster was used for a splendid series of figure sculptures and busts, which date from the third millenium BC. Some of them are preserved in the Louvre in Paris and they are amongst the most striking portrait sculptures ever made. Although ancient alabaster went on being used in old Mesopotamia,

9

modern alabaster (hydrated sulphate of calcium), was also used, in particular for the most splendid wall decorations of all time, the bas reliefs of the Kings of Assyria in which they record their triumphs over rebellious peoples, enemy cities, or the great beasts of the chase, such as the lion. Perhaps because modern alabaster does not offer such a hard and glossy looking surface as the ancient kind the Assyrian craftsmen were never content to leave it as it came from the chisel. Instead the surface of the completed bas relief was painted and gilded in natural colours, just like a mural painting raised in relief. Traces of the original paint are still to be seen on the bas reliefs from the palaces of Assyria brought back by Layard and other archaeologists and now housed in the British Museum. It is worthwhile looking at them just to see the striking detail which can be carved into alabaster—down to the claw in the lion's tail with which it keeps its mane and coat in good condition—to the blood pouring from an animal transfixed by the king's arrow. Alabaster was also used in ancient Mesopotamia for cylinder seals, which, as will be seen in a moment or two, were also carried out in another of our materials, steatite.

Because onyx marble is hard and glossy and with a wonderfully variegated pattern of colours, it was widely used for interior and exterior architectural decoration. As it was impervious to water, unlike modern alabaster, it figures largely in the buildings of those ancient cities such as Carthage which happened to be near enough to alabaster quarries to make it practicable to use the lovely variegated onyx marbles. It was used so much for the decoration of temples and houses that certain colours acquired special names. It was a lot easier for craftsmen to carve an alabaster vase in many parts of the ancient world than to get together enough fuel to fire pots—wood was very scarce, both in ancient Egypt, and in Greece, which was virtually treeless. Consequently ancient alabaster became very popular for vessels of all kinds. This is supposed to have given it its name, which comes from a Greek word meaning 'difficult to hold', because alabaster bottles slipped through the fingers. However, some people feel the name of the stone is derived either from a town called 'Alabastron' in ancient Egypt, or from a Greek Island of the same name. The most famous of all the containers made from ancient

alabaster is of course the bottle containing the precious ointment which the women at Bethany poured on the head of Jesus. However, it has an even more unusual use: that of holding tears. As Roman mourners followed a funeral they held little bottles called 'lacrymatories' to their eyes to catch the tears which fell from them. Just before the dead man was placed in the tomb they stoppered the bottles and placed them beside him. Lacrymatories were made in other materials than alabaster, such as glass, so that you could show how much you had wept, but we do not know whether the potters copied the widely used shapes of these bottles from the alabaster carvers, or vice versa.

In medieval times England took the lead in alabaster carving. The easily mined and easily worked stone began to be used in enormous quantities for the production of carvings for the church: altar pieces, stations of the cross (*see illus. 2*), figures of saints, and so forth. The English medieval carver was not content to leave the material in its natural state once it was finished any more than the Assyrian sculptor had been: all the carvings were wonderfully painted and gilded, and much more of this colourful work has survived till our own time. Other medieval countries admired our alabaster altar pieces so much that they became an important item of export. They were bought for churches far across Europe in Hungary and Italy, and even as far as Iceland, where three English altar pieces are to be seen in the national museum. Unfortunately, with the coming of the reformation many of the altar pieces in English churches were destroyed. Some congregations, however, buried their treasured alabaster carvings until extreme image-smashing, Puritan views had ebbed. Then they brought them out and restored them to the church. Other altar pieces have returned to England from the continental churches which they once graced, and there is a fine collection of them in the Victoria and Albert Museum, and also in the Alabaster Museum in Nottingham.

Even when the reformation had put an end to making any new church images or altar pieces from alabaster the sculptors were able to keep their workyards going because a fashion for alabaster tomb monuments began. Like the altar carvings which had preceded them the tomb figures and tomb work are some of the best of all English

craftwork and sculpture. The soft creamy stone was carved so as to show the finest and most minute detail, such as the hair or eyelashes of the dead person, and even to suggest what could not be shown, such as the cling of the shroud to the corpse who was laid out naked except for this thin garment. Now for the first time some of the tomb figures were just sculptured, not painted and gilded as well. However for a long time the two fashions of working alabaster ran side by side, so that you would find tombs with some parts painted and gilded, others left in the natural polish. An alabaster tomb, judiciously restored in the right heraldic colours, goes a long way to light up a dark and gloomy church.

Besides being used for churches, alabaster was used for architectural decoration but only inside, because if used on the outside of a building it would first begin to weather and then eventually dissolve. Alabaster slabs were used to line staircases, and for stair balustrades, which could be turned on a lathe. They were worked into urns and large ornamental pillars, the largest of which are those at The Hayes Conference Centre, Swanwick, Derbyshire, where they stretch from ground to ceiling inside what was once the hall of a stately mansion.

Although much alabaster was carved for ornaments in England the centre of alabaster carving, in the nineteenth century, was in Florence and nearby towns where the alabaster mined at Castellina was worked into vases, clock cases, busts, statues and figures of animals. One Victorian visitor to Whitby in Yorkshire complained that he could not even go into a souvenir shop without seeing the classic features of Victor Emmanuel staring at him from an alabaster card tray! Sometimes the alabaster workers made the material more opaque by dipping it in nearly boiling water, and then called it 'marble of Castellina'. Many of these Italian alabaster ornaments may still be bought, often very cheaply.

Steatite, or soapstone, has an even longer history than alabaster, because as it is so soft (it can be scratched with a finger nail) it probably started being carved before the slightly harder alabaster. It has also been put to some odd uses. It was eaten by Indians in North America and Africans on the banks of the Senegal, used as soap by the Arabs, sawn into slabs to line furnaces and baths, used to mark

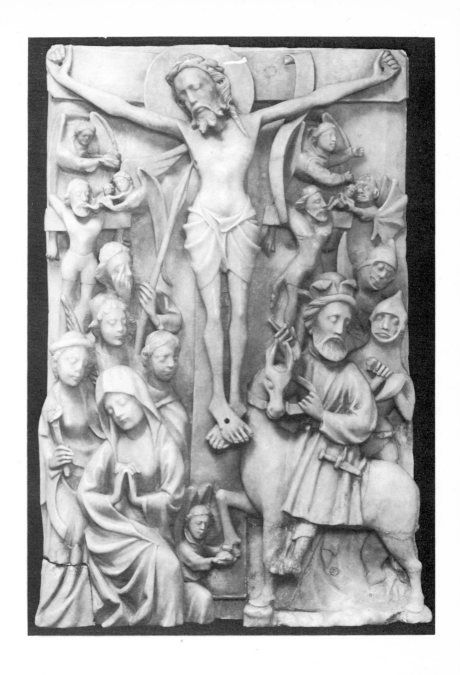

2. Fifteenth century English alabaster
panel showing Christ on the cross. *Victoria
and Albert Museum, London*

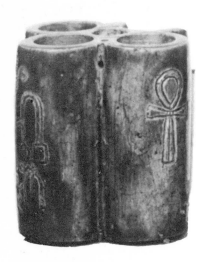
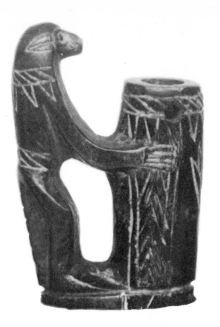

3. Containers for cosmetics. Ancient Egyptian. The first is made from steatite which has been glazed (possibly by firing in the way I have described on page 47). The second is made of unglazed steatite. *British Museum, London*

cloth, and as a slate pencil in Burma. Because it will stand heat very well it has always been a favourite material from which to make cooking pots, lamps, and stoves. The ease with which it can be worked has meant that it could be carved, either by primitive people who had a very primitive technology, or by those more advanced who wanted to make a lot of carvings in a hurry. The polytheism of old China might well have been impossible without this very useful and workable stone.

Soapstone carving began in very early times. The ancient Egyptians made scarabs from steatite, while the inhabitants of Assyria, Babylonia, and the Indus Valley civilisations all used steatite for stamp and cylinder seals, the practice having been no doubt passed from one to another. The craft has never died out in India. Soapstone is used for carving cooking pots which do not have to be broken after use, as do certain castes with their pottery ones. It has been used to build palaces (its poor weathering qualities being, apparently, not too important in dry climates), turned on a lathe for balustrades, and

4. Mediaeval Indian soapstone carving,
India. *British Museum, London*

carved into attractive birds and other statuary. The Indian carver of today marks out his sculpture with a piece of bamboo dipped in pigment, and then carves it by means of thin chisels with flat edges struck by hammers. A long pointed chisel is used for the final dressing. The soapstone is polished with steel powder, made by pulverising a lump of steel with a hammer, which is rubbed on with a rubber, a quarter of an inch by five inches long, made from a heated mixture of sealing wax and *karvundam* (a siliceous rock) broken into powder, mixed in equal proportions. The final polish is given by steel powder applied with a lead brick. This turns the stone black, and very glossy. Soapstone carvers are sometimes an hereditary caste, such as the Amaris in Devanahalli, Bangalore, India, and centuries of carving have given them all sorts of special skills. They can carve chains of linked rings or turn out very complicated trifles which are often pierced with fretwork. It takes them less than a forenoon's work to carve an ornamental bird. Soapstone carving reached its highest exposition in Indian hands, with fine decorative work, such as that in the Orissa temples, or statues of gods, like those bought by pilgrims at Pari as a memento of their visit to Jagannath, or the more monumental type of temple statue, some of which are illustrated here and on *page 61*.

In China, soapstone carving has always been confined to a few areas. Its traditional home is Fukien province, particularly in the cities, such as Fu Chou. Chekiang province is also an important centre. Much soapstone was used in Ming and Ching times particularly for idols, carvings for the study table, flower vases of all sorts, and seals. Seal carving was one of the very few real crafts to which the *literati* of old China deigned to turn their hand. An artist or a calligrapher might use hundreds of different seals during his lifetime. Each of them had to be calligraphically perfect, and they were cut with a knife. They show a delicacy of touch often missing from the cruder kind of soapstone carving, such as the flower vase which I illustrate (*on page 20*).

Jet and cannel coal have a very long history as artistic materials. Jet was worked in Yorkshire in Bronze Age times and many objects made in it were exported to Scotland or Ireland. It was also popular with the Romans, who carved from it finger rings complete with hoop

and bezel. During the Middle Ages the jet carving industry of Yorkshire flourished and the carvers made crucifixes and beads with a knife and file. During the nineteenth century machinery began to be used and jet was then shaped on a lapidary's wheel. The industry boomed and orders poured in from all over England and America and even from foreign royalty, such as the Queen of Prussia. However the very success of jet carving spelt doom to the more artistic side of the industry, standards of workmanship declined and jet ornaments lost favour.

Meanwhile in Spain a very productive jet industry with high artistic achievements had grown up during the middle ages, devoted to making statues of saints and other religious emblems for the pilgrim trade, only to die out completely by the eighteenth century. Jet was also carved by many primitive societies, such as the Zuni Indians and Eskimos.

Turquoise has been widely employed for jewellery since a very early period. Its principal use as a sculptural material is found in the turquoise mosaics made by Aztec craftsmen in Pre-Columbian times.

Materials, and How to Obtain Them

Lots of people have been stopped from becoming sculptors right on the threshold of the art by the hardness of many sculpture materials and the difficulties inherent in working them. However, all the materials described in this book are soft enough to be carved without any difficulty. They are all softer than hardness 6 on the Mohs Scale. This is a table of comparative hardness of minerals worked out by the German geologist Friedrich Mohs (1773–1839) who tested most of the known materials for hardness. Practically speaking, a hardness of less than 6 means that all the materials described in this book can be worked with a riffler, or a file, as well as by carborundum and other abrasives. Those which have a hardness of less than 5 can be carved with an edged steel tool. I may say in passing that if in this or subsequent chapters I have little to say about a particular stone, such as sodalite or orthoclase, that need not mean that it is not worth carving. It may mean that none was available while I was writing this book, or that I did not consider it sufficiently attractive artistically to be worth while carving. However this is just my opinion, and the reader would do well to experiment for himself.

Good materials make all the difference to a carving. I experienced this truth at quite an early age when I began to pick up pieces of tailor's chalk (steatite) from my father's work room table and start carving. Although I soon mastered the art of holding a razor blade (used by tailors for ripping out) slightly bent so that it did not gash my fingers, I found that the chalk, (which came in triangular flat pieces) was the wrong size and shape for the carvings I wanted to make, while at the same time I found it almost impossible to fasten pieces of it together into a combination carving. So it is worth while taking some trouble to get just the right materials.

Clunch

The first material I am going to discuss in this chapter, clunch (which is a carvable variety of soft chalk) has all the merit of being readily accessible. A delightful story is told of an artist on a sketching tour of

the South Downs who began sketching a sunset. Barely had he got started on the drawing before he realised that it was going to be his masterpiece, the best picture he would ever draw. Then, when he was nearly finished, he realised that one thing was lacking. A touch of white here and there. Unfortunately he had used the last of the white chalks earlier in the same day. In despair he gazed from the sketch to the fast fading sunset, and saw his hopes of fame and fortune fading with the sun. Then, all at once he recollected that most of southern England is made up of chalk. He pulled up a turf, broke off a piece of chalk, and completed the sketch.

Chalk

This is a soft white, earthy carbonate of lime, made up of innumerable minute marine fossils. It does not possess the weathering qualities possessed by harder stones, as anyone who has compared the inroads made on the white cliffs of the south of England with the sandstone cliffs of north-east Scotland will have noticed. It is, however, an ideal carving material for children and beginners in sculpture. It is quite common in England, and there is a list of quarries on *pp. 87–90* which tells you where you can buy chalk. If you have decided to make a massive sculpture in chalk I suggest you visit a nearby quarry, armed with a heavy hammer, wedges, and sacking for wrapping the chalk, and wedge off a piece the size you require before having it wrapped and delivered by lorry. However, I suggest you begin not with a large carving, but a small one. Examine the detritus at the foot of a cliff and pick out a piece small enough for you to carry home. Don't forget to enquire which are the really dangerous parts of the cliff and avoid them. A walk along the shore at low tide will also yield chalk boulders and pebbles in all sizes. These are useful, because the pounding of the sea has broken up the very softest and most friable pieces of chalk (leaving you with something which is usually fairly workable) and has, besides, partly shaped the blocks for you into ready made shapes which are almost abstract sculptures in themselves.

Building sites, motorways under construction, and any other engineering project will also yield raw chalk. A friendly word, and a tip, to the works foreman or night watchman is usually sufficient to enable you to carry away as much chalk as you want. Avoid pieces of

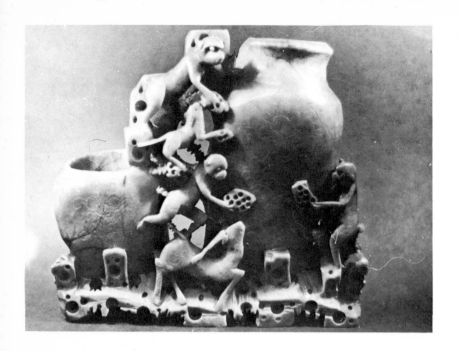

5. Nineteenth century soapstone flower holder, traditional Chinese. *Author's Collection. Photo Mrs. Stella Reed*

clunch with lines of small flints embedded in them, or protruding from them, those which are badly weathered, or obviously discoloured, or dark and gritty. Tap with a hammer to test the consistency of the chalk. Boulders too large to be carried away can be split in two by wedges and a hammer. If brought back in the boot of a car, individual lumps of chalk should be wrapped separately in sacking.

Soapstone

This (otherwise known as steatite) is a variety of talc, the softest of minerals, with a hardness of only 1 on the Mohs Scale. It can be scratched with a finger nail, has a greasy appearance and occurs in a wide variety of colours, which include: white, grey, yellow, green, red, brown, and black. (A variety of soapstone, found in China, differs from the normal kind by containing six per cent of potash. It is called Pagoda Stone, Figure Stone or (regrettably) Algamatolite—which

20

just means 'figure stone' in Greek.) It is found in many parts of the British Isles (I refer you to the Map of Soft Stone Deposits on *page 22*) including Lizard Point, in Cornwall, mixed up with the veins of serpentine there, again in combination with serpentine at Portsoy, Aberdeenshire, at Uist in the Shetlands, and in Wales (where blocks of serpentine have been built into the outside walls of Beaumaris Castle, in Anglesey). Of course if you live near any of these localities you should visit rock falls, cliff faces, excavations, and so forth, and collect your own material.* Otherwise, buy soapstone from the most convenient rock shop in your area. Most of what you buy will come from Barberton in the Transvaal, and it is very good working material. For collecting purposes, the soapstone and serpentine areas are virtually the same. Serpentine too can be bought from a rock shop, and it is not expensive.

Alabaster

This can be of two kinds, *modern alabaster* which is gypsum, and *ancient alabaster,* which is onyx marble. *Gypsum alabaster* is a hydrated sulphate of calcium, white, pink, or greenish in colour. A special variety, known as *satin spar* provides material suitable for making jewellery. It is an aggregate of finely fibrous crystals which occurs at East Bridgeford in Nottinghamshire, where it used to be made up into beads and other ornaments. It has a sheeny surface which shows a marked colour change when held up to the light and moved to and fro. *Anhydrite* is another variety, found near Newark on Trent. *Selenite* is completely transparent and apparently has never been used for carving, so it offers an open field for experiment. Completely clear alabaster can be made to look like marble by dipping it in nearly boiling water, but this will not deceive anyone who cares to draw their sharply pointed nail across the spurious marble, and I merely mention it here as a matter of interest. As a fingernail has a hardness of 2·5 on the Mohs Scale (sharpened finger nails make quite effective weapons and Roman schoolchildren used to trim theirs neatly to a point by way of getting ready for a fight) it follows that modern alabaster cannot be harder than 2·5 and is usually softer. It is

* See also the list of addresses of quarries, etc. on pp. 87–90.

A MAP TO SHOW SOFT STONE DEPOSITS IN THE BRITISH ISLES

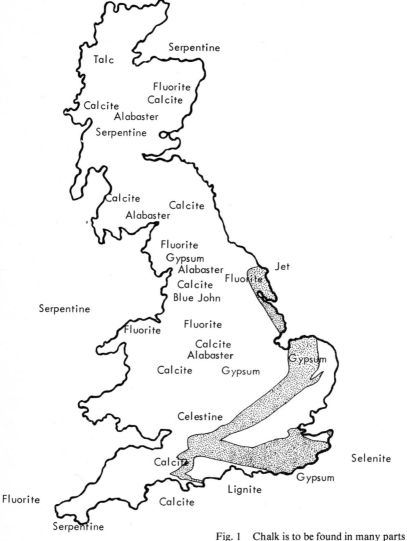

Fig. 1 Chalk is to be found in many parts of the British Isles, particularly in the shaded areas indicated above. Wherever serpentine is indicated above, soapstone will be found in the same area. A similar map of soft stone deposits in the USA will be found on p. 79

found in Staffordshire, at the Fauld Mine, and Aston Glebe Mine, Chellaston, Derbyshire. It can be collected near mining areas, or bought as offcuts from craftsmen who work it in Derbyshire or Staffordshire. Nodules of alabaster can be bought from mineral supply merchants. These are big enough to make small carvings, but they may be made up of stone too soft to be used for sculpture. After all, they are of interest to the mineral supplier just because of their geological structure. They should be bought with caution and tested by pressing them between the fingers before they are carved. A fruitful source of alabaster is old ornaments, such as book ends and the like. These have become so badly scratched with wear that they can usually be bought cheaply, and recarved.

Ancient alabaster, or onyx marble, is made up of calcite, a carbonate of lime, which is deposited on the floor or roof of limestone caves by drops of water percolating through the limestone and building up ascending and descending cones, called 'Stalactites' if they hang down, 'Stalagmites' if they rise from the floor. These will be familiar to anyone who has ever done any caving; the temptation to collect them on caving trips must however be curbed by a desire not to spoil the amenities for future visitors. Moreover, much more decorative onyx marble than that obtainable in England can be bought very cheaply from abroad. Onyx marble is also deposited by the hot springs of volcanic regions (i.e. the material thrown up by the geyser in Iceland, which has the technical name of *geyserite*). Onyx marble is much more translucent than the gypseous kind. It is highly crystalline in composition and shows the flow patterns resulting from the gradual swirling down of the calcite solution which built it up drop by drop. When cut and polished it shows a wonderfully variegated and banded pattern. With a hardness of 3 on the Mohs Scale, ancient alabaster is slightly harder to carve than the gypseous kind. However it is much more long lasting, and much more decorative. Onyx marble is rarely colourless, much more usually it is green, yellow, or tawny pink. The colours are due to the presence of impurities which have seeped in with the calcite solution. Iron, for example, will colour onyx marble brown or red.

Deposits of ancient alabaster occur on the left bank of the Avon near Bristol, Matlock in Derbyshire, Settle in Yorkshire, Aston

Moor in Cumberland, and Shotover Hill near Oxford. Very attractive foreign onyx marbles can be easily and cheaply bought from mineral suppliers. A splendid emerald colour comes from Peru, a beautiful creamy variety from the Argentine. In Mexico, where much onyx alabaster is mined, it is worked up into attractive carvings, such as chessmen.

Cotham marble

Cotham marble, or *Landscape marble* is one of the most extraordinary and attractive of all stones, and so far as I know, is only found in England. It is found at Cotham, near Bristol, and is a Jurassic mudstone, which petrified round the seaweed growing on an ancient sea bed. Because calcite was deposited around the different levels of the living seaweed—that is, the sea bed, the stalks of the weed, and the bushy tops—the stone displays an incredible pattern resembling a landscape, with roads, hedges, trees, and streaky sky overhead. Cotham marble has a hardness of 3. When possible it should be used in a cross-section so as to display the natural pattern.

Serpentine

Although it may be possible to see a landscape in Landscape marble it is difficult to see any resemblance to a serpent in Serpentine. This hydrated silica of magnesia and iron occurs, as has been already noticed, in conjunction with soapstone. Precious serpentine is translucent, massive, and of a uniform green or yellow colour. It varies in hardness from 2·5 to 4 on the Mohs Scale. Serpentine is such a decorative stone that it has been popular since Roman times. A variety of it, re-discovered in the renaissance period, acquired the name of *verde antique*. This is green mottled or veined with white calcite or dolomite. Much statuary has been made in this material, especially under its British name of *Connemara marble*. It is in such demand for ornaments that quantities are exported from this country to Germany and then reimported as finished work.

Malachite

This is a soft stone just inside the boundary which separates statuary material from that used to make jewellery. It is a hydrated carbonate

of copper, coloured bright green, and arranged in banded patterns of different shades. It has a hardness of 3·5 to 4, and although much used for jewellery, did also serve as a sculptural stone, especially during the nineteenth-century Decorative Period. It can be found in England at Redruth in Cornwall. It can also be bought in rock shops.

Verdite is similar in appearance to Malachite but differs from it in being a much harder stone, with a hardness of 4. Present supplies come mostly from Barberton in the Transvaal, South Africa, but it may soon be discovered in workable quantities in England. Verdite is extremely ornamental, and it can be seen, to good effect, in the massive columns standing in the Bank of England.

Turquoise

This is the soft stone which is most often used for jewellery, but the Chinese make small statues from it as well. It is possible to buy turquoises sufficiently cheaply to allow them to be carved by the amateur. Turquoise is a hydrous phosphate of aluminium, with a hardness of 6 on the Mohs Scale, so it will act as a useful 'bridge' between soft and hard stone. It is green, blue, apple green, or greyish green. Like the three previously mentioned materials turquoise must be bought from a mineral supplier or rock shop.

Fluorite

Fluorite on the other hand, is quite a common British mineral. It is a calcium fluoride compound which can be colourless, white, green, purple, amethyst, yellow, or blue. The purple or blue variety is known as *Blue John*. It is the most prized of British minerals, and it may have constituted the famous 'Myrrhine cups' which the Romans deposited in the temples of the gods as being too precious for ordinary mortals. Part of the costliness of Blue John comes from the difficulty experienced in working it. The stone has to be 'frozen' by a shellac solution before being turned or carved into ornaments. Fluorite is of course a fluorescent mineral, as its name implies. It has a hardness of 4 on the Mohs Scale and can be worked up without too much difficulty.

Kimmeridge shale

Another British mineral that was much prized by the Romans is

Kimmeridge Shale, an argillaceous rock used in Roman Britain to make jewellery (chiefly in the shape of turned bangles) and for furniture fittings (*see illus. 6*). It has been undeservedly ignored by British sculptors since Roman times. Of roughly the same composition as Cotham marble, it is somewhat softer. It comes from various localities in the British Isles.

Lignite and Cannel
These are varieties of coal which also attracted attention from British craftsmen in Bronze age and Roman times. They were used in conjunction with jet to produce some of the finest jewellery of the period. Lignite is a brown coal which is half way between peat and hard coal. Cannel coal is another variety of coal which will ignite in a candle flame and then burn smokily. Apart from providing an easy solution to what to do with a sculpture which you do not like and do not wish to keep, lignite and cannel coal could be used for decorative candles, though no-one has yet used them for this purpose to my knowledge. Whereas cannel coal is black and glossy, lignite looks brown at first but later polishes black. Lignite is very soft, about 1 to 2 on the Mohs Scale. It is often flaky and fissured, but it can be frozen with shellac. It occurs at Hanover point on the Isle of Wight and other British localities. Cannel coal is found at Torban, Boghead, and other localities in Linlithgowshire, Scotland. Both can be readily and cheaply bought from mineral suppliers. Jet is so like the other two materials I have just described that it may be sufficient to say that it is a fossil driftwood, found at Whitby in Yorkshire, and distributed down the whole of the East Coast as beach pebbles.

Amber
This is a fossil resin, washed up on the beaches of Eastern England, or mined in the Sammland Peninsula in Germany, and also in Burma. It has a hardness of 1–2 and while it is very easily carved, is also very brittle.

Meerschaum
This is a clay mineral which belongs to the sepiolite group. It is a white chunky earth, very light and very soft to carve, which has been

6. Romano British turned elements for furniture in Kimmeridge shale

compared to 'sea foam', hence its name, a German translation of 'sea foam'. A hydrous magnesium silicate, it is found in Turkey, where it has been worked for over a thousand years. The Greeks used it as soap, and in North Africa and Spain it was used for building blocks. With the coming of the eighteenth-century meerschaum began to be carved into pipe bowls. It has become such a well-known art material that I have introduced it here, with the suggestion that it might be carved into other forms than pipes. Supplies of meerschaum are obtainable from Tanzania in the form of rough block pipes, which can make ideal raw material for carving, as they have been put through a hardening process which makes them more resistant than raw meerschaum. One obvious outlet for meerschaum sculpture (apart from pipes) is for floating sculpture, which can be displayed in bowls of water as table centre pieces.

Many other soft stones, such as aragonite, a snowy white mineral with a hardness of 3, could be considered under the heading of raw materials. From time to time during the subsequent chapters I will

27

refer briefly to other materials such as travertine, and give instructions as to how they can be carved. Most if not all soft materials are capable of producing sculpture. There are one or two exceptions. Pure talc is so soft that nothing can be made from it, while **Realgar,** a substance much carved by the Chinese, is an arsenical ore and thus extremely poisonous.

7. Victorian jet jewellery. Made by
Edward Pearson. *Photo Mrs. Stella Reed*

Studio and Equipment

Although during this chapter I will mention what tools and equipment I feel are necessary to set up a really well equipped studio, it is not necessary to possess all these tools to make soft stone carvings of superlative quality. A simple knife was the sole tool with which some of the old Whitby jet carvers made very intricate jet carvings, cameos which were faithful portraits, necklaces of linked rings cut out from a single block of jet, and so forth. So do not be dismayed if you feel that, just at present, you cannot acquire all the tools I suggest. Begin with just a few and gradually add to your stock. You can usually improvise a do-it-yourself tool kit which will be a substitute for the one you would like to buy later on. Thus the daughter of one of the jet carvers mentioned above used to mix her father's jet cement, made from lamp black and shellac, in a bowl on the kitchen table. Don't delay too long in buying the right equipment however. It is always the shortest cut to the desired end to have the right tools. A carving made with a penknife instead of proper sculptor's tools may be a masterpiece made the hard way. I have assumed that anyone who becomes interested in carving one kind of soft stone will eventually want to carve them all, and also experiment with other soft materials. To carve all the different kinds of stone described in this book really requires a full range of tools, especially if the carver is hoping to exhibit them, or sell them as craft products. Some of the materials which I describe stand halfway between those which can be carved with craft tools, and those which require the tools of the sculptor. I shall describe both craft methods, involving the use of time-saving techniques, as well as the more orthodox sculptural ones.

The Studio
It is a great advantage if you can get a studio; however, no studio is better than a bad one. Ideally suitable is a room in a dwelling house, sufficiently detached (say by a short corridor) from the living and cooking parts of the dwelling for the inhabitants to go on with their normal routine without feeling that they are living in a perpetual at-

mosphere of dust and stone chips. The studio should be centrally heated and should have a comfortable temperature in winter and summer. Do not settle for a shed in the garden. This is a snare. It is a mistake to imagine that you can go on carving there winter and summer with no heat except a paraffin stove or a tiny electric fire on a long lead. After shivering in the draughts which pour through the cracks in these ill-constructed buildings, becoming overheated on one side and chilled on the other, you come out to a full blast of cold air when you leave. Garden studios rust tools, or warp them. They affect a sculptor's productivity during the winter adversely. Usually he simply cannot face the journey down the garden at all. Two very successful lady sculptors whom I know who have a garden studio never seem to work during the winter at all—I can only suppose that they make up for this forced inactivity by working overtime during the summer. Worse still, cold garden studios can undermine a sculptor's health.

By contrast, let me describe a studio which I visited and which belongs to Gwynneth Holt (who in private life is Mrs. Gordon). She has converted a room in her charming Tudor cottage into an ivory carving studio. It is quite a small room, but only a few steps away from the living quarters. Though lit only by two normal-sized windows, and opening onto a busy street it is perfectly adequate—as the sculptor's wonderful ivories show for themselves. Just because it is part of the house it is even more beautifully arranged and in apple-pie order than a separate studio would be.

If you decide on an indoor studio, choose a small room with a good outlook for light, looking south if possible. Place your bench directly under the window, and supplement the normal artificial light by a bulb holder, carrying a 100 or 150 watt bulb, which can be moved about to focus on the work on hand. If you have a prejudice about using artificial light, remember that some of the best sculpture in the world, such as that in the Cave Temples of Ellora, were carved under this sort of illumination.

Bench

Get a good bench, and make sure it is sufficiently braced by cross struts to take the strain of any heavy work, such as chiselling a piece

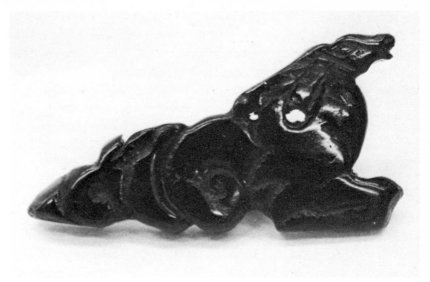

8. 'Sea Horse', Contemporary jet carving. Made by the author

of stone placed on it. Fit a Scopas vice to the side of the bench which has the best natural light, and attach another, smaller vice to one of the short sides of the bench. This will serve to hold an electric drill, (make sure your power point is nearby) which can be used to power a flexible drive to hold rotary files. These will be useful for grinding away particular hard veins of stone, and for carving the harder soft stones. Engraving bits can also be fitted to the flexible drive to engrave the designs of seals or scarabs. Used unclamped and free from the vice, the drill will prove invaluable for holding an arbor which will carry abrasive disks made from cintride to carve down the surface of the harder stones—such as Cotham marble—or sandpaper disks which will be used for sanding down various kinds of stone, preparatory to their being polished. A portable grindstone can also be used for this purpose, and when the drill is not being used for any other purposes, it can be kept in the chuck, with the drill clamped in the vice, so that it will be available for sharpening the edges and points of chisels which have become blunted. Keep a plastic cup handy to contain the water which is necessary for tempering tools which become overheated while being used.

Storing tools

In a cupboard on the wall above the vice store everything which will be used with the drill; the tightening key, rotary files, engraving bits, abrasive heads, flexible drive, arbor, sandpaper disks, abrasive disks and sandpaper, in that order downwards, so that the smaller tools are at the top of the cupboard and the larger at the bottom. Keep small tools in transparent plastic jars. Try to keep your twist drill and its drills completely separate from the power drill. This will save you making a mistake and using slow speed drills in high speed equipment. Have a stop on the bench against which you can press a piece of soft stone while you are planing it. Keep your planes and surforms in another wall cupboard, along with an oil stone, an oil can, and a piece of Arkansas stone for sharpening tools. A cupboard well away from the heating source can hold the inflammables: a bottle of paraffin, and one methylated spirit for the spirit lamps, the spirit lamp itself, and a bottle of sweet oil.

Saws

Carpenter's saw, hacksaw, cabinet maker's saw, coping saw, fret saw, and piercing saw should be kept hanging on the wall. This will help to remind you if they need cleaning, or sharpening. Have a miniature whitewood cabinet fixed to the wall to contain the blades for these saws, ranging in size from the smallest at the top to the largest (hacksaw) at the bottom. Label the drawers with Dymo markers.

Abrasives

Have a separate cupboard (close to the floor, so that spillages will not make too much mess) containing all the polishing materials: sandpaper of various grades, water of Ayr stone, abrasives such as emery powder, powdered pumice, tripoli, precipitated chalk, putty powder, crocus powder, powdered shellac, aerosol bottles of shellac in solution (such as are sold in art shops for fixing chalk and crayon drawings) terrazzo sealer, silicone, plate polish, and wax polish. You should keep an ample supply of polishing cloths, torn up cotton pyjamas, Jay cloths, and Kleenex. Because soft stone carving may make you want to branch over to carving harder stones, why not set aside an empty cupboard now for the polishes you will want if you turn to hard car-

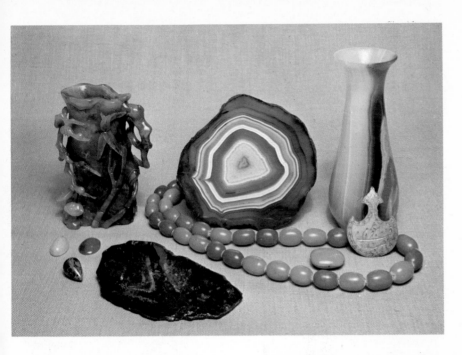

A wide range of carved and polished minerals. *Institute of Geological Studies.*

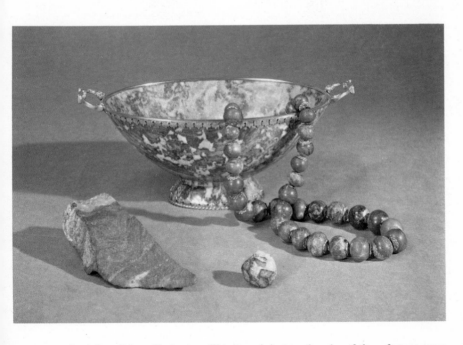

Lapis-Lazuli from Turkestan. This stone is just on the edge of the softstone range but can be worked with a file. *Institute of Geological Studies.*

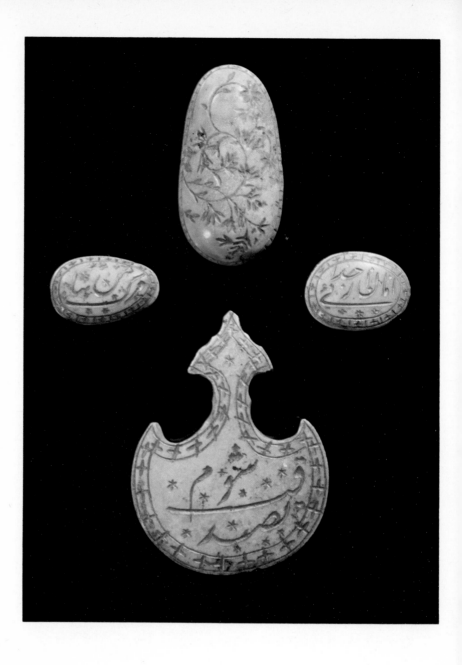

Turquoise, from Persia, carved with an amuletic inscription inlaid with gold.
Institute of Geological Studies.

ving? They include emery stone, coarse sandstone, fine sandstone, pumice stone, English bone, and oxalic acid. Some of these can also be used on soft stones as well.

Storing other equipment

You can keep all your extra soft materials in a cupboard, which should contain bars of soap, and soap ready cut and mixed up with water so that it is of a soft consistency. Here, too should be kept boxwood and wire tools for modelling soap and wax, old blunted craft knives, plastic knives and toothpicks and spoons, ready cut non-ferrous pins for pinning arms, heads, and legs to soap statues, a stock of floss silk for making up hair for soap figures, and a bottle of sodium silicate for cementing pieces of soap together. In the same cupboard you can keep sticks of modelling wax, blocks of paraffin wax, with oil colours for colouring wax figures or busts and poster colours for colouring soap sculpture. A stock of brushes can be kept here, together with all the material necessary for soapstone printing and gold stamping. This includes printer's ink, dabbers, ink thinner, and old cloths for cleaning, books of gold and silver leaf, skiver, a tripod, and asbestos mat.

Racks

Chisels, gouges, wood engraving tools, mallets, files, and rifflers, alabaster knives and plaster rasps, are best kept in racks at the back of the bench, where they will be within reach at a moment's notice when required. Keep these tools in a definite order with the sizes marked both on the rack and the tool with Dymo marking tapes.

Maintenance

If the studio offers sufficient storage room, keep all your stone there. You will thus be able to see, at a glance, what pieces are available for a particular commission. Unless stored properly, stone shows a deplorable tendency to roll under the workbench, get chipped and broken, blunt tools, and accumulate dust. Rock shops, which market stone in smaller sizes, provide useful hints as to how it should be stored; they themselves keep their materials either in multi-shelf racks, or in large bins with lids which prevent the dust spreading out into the

Fig. 2 Plywood bin to hold rough stone, approx. 1 square metre

shop. I have drawn a sketch (*Fig. 2*) of these two kinds of storage containers, which you can easily make for yourself, and which will hold everything except the smallest and most expensive kinds of stones, such as turquoise, which can be kept in drawers in miniature white wood cabinets.

It is worthwhile making the utmost efforts to keep down the dust in a studio. Keep a large polythene sheet which you can unroll on the floor every time you are unpacking or sorting stone. When you have finished, take the sheet outside and shake it to remove the dust. Have linoleum laid on the studio floor, and throw wet sawdust on it before sweeping up, which you should do at least once a week. An even better plan is to vacuum the studio once a day. If you are going to carve a stone regularly, wear a respirator to make sure you do not inhale it. Wash down raw stone with a hose outside the house before you store it away in the bins. Keep tools and other equipment under plastic covers when you are not using them. You can make these covers very easily from plastic delivery bags. Brush down your equipment regularly. Fit an extractor fan to a window, and switch it on while work is proceeding.

A tidy studio will not merely increase your productivity, ensure that you keep fit, and are not distracted from the essential business of carving by minor irritations, it will also impress any patrons whom you bring in to inspect your work. Don't forget to allocate storage room for finished work which can be produced to go on exhibition. Place finished carvings in labelled boxes and keep a check list of the contents, as well as a note of what sculptures have been sold to patrons,

and which can be borrowed back for exhibition. Other essential records are a scrap book with photographs of past work, a supply of prints which can be lent to magazines which want to illustrate your sculptures, designs and sketches for new work, addresses of suppliers of tools and stone, of patrons, galleries, and art societies. Know the dates of the principal exhibitions by marking them in a special calendar. Even if you never mean to exhibit, it is still a good plan to attend such exhibitions regularly. By doing this you will meet fellow sculptors, patrons, and art critics, all of whom are essential contacts. You will also keep in contact with modern sculpture.

Acquiring a Technique in Alabaster

I would suggest that alabaster should form the reader's first introduction to soft stone. It is cheap, easy to obtain in Britain, and easy to work. It is also highly decorative. As no project can be too simple to begin with, a simple alabaster paper weight, of the kind ones sees in luxury stores and fashion magazines, will serve for the initial project.

Select a suitable sized lump of gypsum alabaster and mark a line across it, considerably below its centre, so as to act as the base for a pear-shaped paper weight. Put the alabaster lump in a vice, and saw through it with a carpenter's saw. No difficulty will be experienced in cutting alabaster, but if you are going to cut a good deal, have ready a triangular shaped file for sharpening the saw and sharpen the teeth at night after you have finished work. Once you have cut the lump in

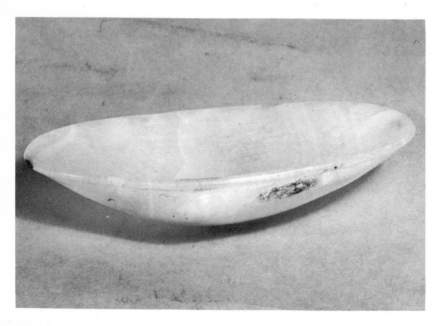

9. Cosmetic dish in the form of a shell, made in Alabaster, Ancient Egyptian (eighteenth dynasty) about 1400 BC. *British Museum, London*

two, stand the block on its base on the bench and mark the exact top of what will be the paper weight. Now use a surform to cut off the rough from the block, working towards and away from the top.

When you have done all the rough shaping which you can with the surform, lay it aside and use an alabaster knife to shape the flair of the paper weight and give it completely smooth pear-shaped contours. One you feel the sides of the paper weight are reasonably smooth, begin sandpapering them. Alabaster creates a lot of dust, and although there is nothing harmful about powdered gypsum (Cheshire country folk used to give their cows scrapings from the alabaster tombs in the church as a tonic) it can be unpleasant to get too much of it, especially on your clothes. So use wet sandpaper, or a cintride rubber or abrasive brick. Finish off the paper weight with the finest sandpaper until it is absolutely smooth. Then take a wet rag dipped in powdered emery and polish it well. Give it a further polish with powdered bath brick or pumice and use, for the final polish, putty powder or tripoli. Alternatively you can use the series of graduated polishing powders which I described on *page 32*. If you want to, you can treat the alabaster with an acid solution. Use a mild one, containing a tablespoon of copper sulphate dissolved in half a litre of water.

One of the best ways of getting a really high gloss on alabaster is to polish it with several coats of wax polish, for it tends to lose its surface polish if subjected to wear and tear. If you have any alabaster ornaments which you want to repolish, treat them with the abrasives which I have described and then wax polish them.

Although too porous to be really suitable to hold liquids, alabaster makes up into very attractive vessels such as ash trays (*Fig. 3*). Make a few of these, basing them on the ancient Egyptian example which I show on *page 36*. This one is made from onyx marble, but can also be worked in gypsum alabaster. If you have no lathe, you can give the sides of the vessel their required flare by making yourself a scraper such as the one which I have drawn in *Fig. 4*. This is cut from some suitable piece of metal, such as an old kitchen spatula, with a metal piercing hacksaw, and ground to an edge. The simplest kind of gypseous alabaster vessel you can make is the oblong saucer from ancient Egypt referred to above. To make this, saw a nodule of

Fig. 3 Ashtray designs based on traditional Chinese designs for ink slabs

alabaster in half. Draw the outline of the rim of the dish on the flat side of one half of the nodule, and then rough it into shape with a surform. Smooth the outside with an alabaster knife and then cut out the hollow of the saucer by going round it in circles with a wood engraver's gouge. Use the alabaster knife to hollow out the inside and make it perfectly smooth. Polish as has been already described.

As a final, and slightly more ambitious project in gypseous alabaster, design a stylised bust, cut it from a block or nodule with a coping saw, and carve the hollows of the eyes and nose with a wood carving gouge. Polish it and set aside until you can make a stand of another ornamental soft stone, such as serpentine or Cotham marble.

Onyx marble is more expensive than gypseous alabaster, and you are more likely to buy it ready cut in blocks than collect it on the site. For this reason it is only sensible to conserve as much as possible of the material you have left over from a previous project. I have

therefore suggested that you should use a block from which you can saw out several ornamental shapes. These can serve either as paper weights, ash trays, or, if made slightly larger than the normal paper weight size, for book ends. They are based on traditional types of Chinese inkstones. There is nothing to stop you making animal or human figures out of onyx marble. You will have to keep them fairly small, because of the expensive nature of the material, but you can capitalise on this limitation by using them as chessmen. I illustrate (*Fig. 5*) a design for a set of chessmen, to be made from Peruvian onyx (green banded with brown) and Argentinian (off white) onyx.

These shapes can be made up in an economical way by sawing out small slabs from the block of onyx marble and then outlining the figures with a coping saw, finally putting in all details with wood chisels, files, scorpers and gravers. Polish in the way I have described for gypseous alabaster, only omitting the wax polish.

Fig. 4 Scraper for hollowing out alabaster bowls, approx. 4 in. across

Acquiring a Technique in Soapstone

Just because nobody has ever investigated the sculptural properties of soapstone before, I shall have a good deal to say about it which may surprise my readers. It has a unique combination of good qualities which are useful to the amateur and professional carver. Soapstone is so soft that it is possible to complete in a few hours a carving which in any other material would take days. It is supposed to be even softer when newly mined and to harden subsequently, though I cannot vouch for this having never carved it fresh. Because it is such a soft material it is possible to make whole series of carvings in it, such as related groups of sculptures for an exhibition, or whole sets of chessmen. It polishes to a beautiful glowing finish with only a little application, not with the hours of hard work with abrasives necessary

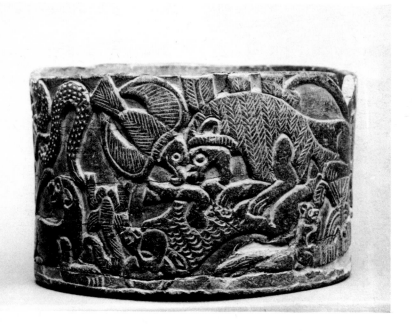

10. Steatite bowl. Sumerian, about 2800 BC. *British Museum, London*

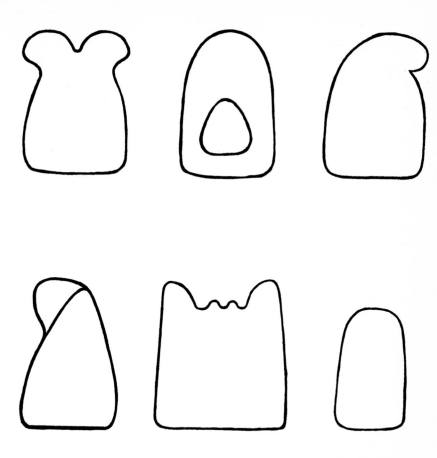

Fig. 5 Simple designs for chessmen in soapstone. *Left to right, top:* King, Queen, Bishop. *Bottom:* Knight, Rook, Pawn

to polish, say, a marble statue. It can be engraved to make frottages or line rubbings without the effort necessary to chisel a line into some harder stone. Its consistency and softness make it the only mineral which can be substituted for boxwood to make stone block prints and stamp seals.

These multifarious uses for soapstone however must not blind us to the fact that it is primarily a sculptural material. In fact, as the reader will see from the Plates at the end of this book, it has been used as a medium by some of the world's greatest carvers.

Polychrome soapstone sculpture

It is worthwhile going to some trouble in the choice of a block of soapstone on which to begin. Colour is important, particularly if you are making a matched set of small sculptures, such as chessmen, or repairing an existing soapstone piece. Another type of sculpture which may make you consider the question of colour with some care is where the design has to be cut through banded layers of soapstone, to show up the different colours of the layers. Important, too, is the structure of the stone. Avoid any pieces which have lines of what appears to be small nodules of iron pyrites running through them. These will show up because the pyrites will be coloured brown and will contrast with the colour of the stone giving a mottled effect. These lines of pyrites are much harder than the basic soapstone and will have to be ground away with steel files or rifflers. On the other hand, they can of course often be turned to good account by utilising the coloured grains of pyrites to suggest, say, the spots on an animal's coat or the eyes of a figure. If you are buying soapstone in a rock

11. Modern African soapstone carving.
By H. C. Kaschula

42

Fig. 6 Candlestick based on a traditional Indian Design

shop and want to know approximately what its polished colour will be, rub it with a little oil or grease, or just rub it on the side of your nose. This will show up the basic colour as opposed to the powdery efflorescence which covers the surface.

Buying the right size

Buy the largest sizes you can obtain—you can always use the offcuts for the smaller projects you have in mind. Although your purchases may be severely limited by what the rock shop or mineral suppliers has in stock, you might care to store what you buy according to the following classification: very large-sized pieces can be kept for making portrait busts and the more ambitious type of large flat slabs for soapstone printing blocks, small pieces with one or more flat sides will be handy for stamps and seals, while small but irregular blocks may be utilised for miniature statues of animals or humans, or for chessmen. Small fragments can be saved for making jewellery.

Bas relief

This is the simplest kind of sculpture with which to begin. Select the largest lump you have available, immobilise it in a vice, and saw off the two longest faces, so that you are left with a slab or plank three inches thick. Unless you intend to make an irregular bas relief trim this to a square. Draw your design onto the slab face, or transfer it with carbon paper. Leave a good margin round the outside of the slab, say an inch. This will protect your design, and also prove useful in mounting it. Mark the parts of the design to be left standing out in white chalk and carve away the rest. Cut the rough out with a claw chisel with detachable head, using a half-inch claw bit. When you cut out the finer parts of the design, use a hammer-head marble claw. Use the finest size chisels and gouges to outline the shape of the bas relief, and incise the finer lines with a short lettering tool. Rifflers of various sizes will be invaluable for smoothing down the face of the relief. The

43

polishing process can be continued with medium, and then fine, sandpaper. Use a flat-edged chisel to render the background smooth. A toothed background with a rough surface can also look very attractive however.

Polish the relief with emery powder, followed by powdered pumice, or bath brick, finishing off with any of the following: putty powder, crocus powder, jeweller's rouge, cerium oxide, or plate powder. The initial coats of abrasive can be mixed with water and applied with a brush, the final ones should be mixed with sweet oil (almond or olive oil) and put on with a cotton rag. Only oil will darken a greasy material like soapstone and bring out the full effect of its veinings and mottlings. Some craft workers use a short cut and simply coat the surface with a filling agent, such as Ronseal or polyurethane varnish, as I noticed the other day while inspecting some soapstone carvings from Rhodesia. I feel this practice is a mistake. Even though Eric Gill once polished a black marble statue with French polish, after having despaired of doing it any other way, it is never a good idea to disguise the nature of any material by painting it over. Moreover, soapstone treated in this way can neither stand outside, or be baked, without the protective coating peeling off. If you do not decide to polish soapstone in the way I have suggested, use some surface finish such as wax polish or silicone. Wax polish, or something very similar was, I suspect, used by Chinese craftsmen on their soapstone carvings. The Chinese have a mania for polishing everything with tallow, even earthenware teapots.

To make a statue or bust in the round, saw off the sides of a block until it is roughly to shape, fix it in a vice, draw a front and side outline with crayon, and then cut away the rough stone with a toothed chisel. Gaps can be cut between legs and arms by drilling and then sawing out the part to be removed with a coping saw. It is easier to do this without splitting the block than in any other kind of material, even wood.

Folk-art sculpture
Although sculpture demands the biggest blocks of soapstone (which you may have to quarry for yourself) simple craft carvings can be made from offcuts. In *Fig. 6* I illustrate a simple candleholder which

can be made from any flat offcut, based on an Eskimo lamp. Select your slab, which should be at least four inches long, and trace the outline of the lamp on it through a piece of carbon paper. Fill in the outline with indian ink drawn with a mapping pen. Lay a piece of carpet underlay on the surface of your bench and press the block down on it with your left hand while with your right you cut round the outline with a coping saw. Choose the flattest side of the block for the top, lay it on the underlay, and gouge out the parts that will be hollow. As this is a small carving, it is better to use a gouge with a handle, such as a wood engraver's gouge, than a stone-cutting gouge. Flatten the bottom of the hollowed out parts of the candle-holder with a riffler. Smooth off the bottom with an alabaster knife. You can also experiment with any of the scratch tools used for handling plaster. A wood engraver's knife will prove particularly helpful for getting into the difficult places. Finish off with sandpaper and polish. No amount of

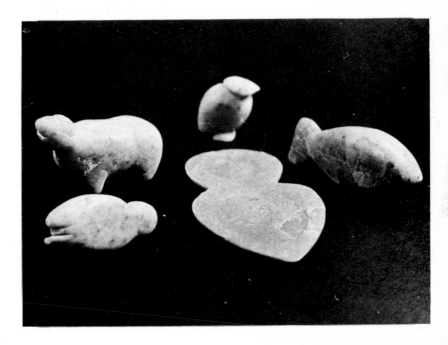

12. Soapstone carvings in the Eskimo style. Animal figures and a candlestick based on an Eskimo lamp, by the author. *Photo Mrs. Stella Reid*

hot wax will harm this candlestick, it will merely improve the polish.

Go on from this first Eskimo style carving to carve some stylised figures in the Arctic manner. These are not merely amusing and interesting to make, they are a real introduction to modern sculpture. Just because they are so stylised they are a lot easier to carve than a fully detailed representational figure would be. They are also undoubtedly the best selling of all soapstone carvings, being eagerly bought, not just by tourists in Canada, but wherever they are on sale. As the Eskimos never even thought of using soapstone for anything except pots and lamps before Canadians and other white men urged them to begin making artistic figures, you are likely to do just as good a job as they do. I illustrate a few figures (*see page 45*) based on traditional Eskimo work. Choose a design suitable to the size of block you have ready to carve, and draw the side silhouette on the block (*Fig. 7a*). Cut it out using a coping saw. Now draw the silhouette of the animal looking frontwise at it. This will involve sawing out between the legs. Finish with the silhouette from on top. This will round out the neck and flanks. You are now left with a blocked out figure standing in a square section, like a wooden toy (*Fig. 7b*). Round off the right angles of this figure by scraping them with the blade of a wood engraver's knife, and a quarter-inch round file. Work gently, it is easy to break off a free standing leg. Cut in the details of the eyes with wood engraver's vee-shaped gouges, and veiners. Cut the hollows for the ears with round gouges. Sandpaper smooth and then brush abrasive into the cracks to finish. Contemporary Eskimo soapstone figures are always polished very highly, so if you want yours to look authentic finish it off with several coats of silicone or wax polish. Procure a small piece of scrap ivory such as a tusk end, and carve accessories for the figures: a horn for the narwhal, tusks for the walrus, and a lance for the human figure.*

Eskimo style sculptures are quite suitable for exhibition—especially such as those given by The Royal Society of Miniature Artists. You may even decide to specialise in them. On the other hand, you may like to progress to carving a whole series of such figures to form a chess set, which I illustrate (*Fig. 5, page 41*). Carving series of small

* I have written comprehensively about this subject in *Ivory Carving*, London, 1969.

figures of this sort is a good discipline. Careful work is essential to ensure that they are all the right size, while the practice you obtain from making a set of figures ought to mean that each is better than the one before. If you do carve this set, remember that it should be made from two contrasting colours of soapstone, unless, that is, you decide to carve one side from alabaster. Soapstone does dye easily in a variety of colours, with pigments mixed with spirit. Modern Chinese soapstone figures are sometimes dyed. However I feel this is another practice which should be avoided, partly because the dye only sinks so far into the surface of the stone, so that any chips or scratches will reveal the figure's true colour. So if you feel you want to make both sides of the chess set in soapstone but of contrasting colours, rub one side with emery powder and a lead brick, as Indian craftsmen do. This will leave the soapstone glossy and black.

Small figures do not have to have a polished surface of course, you can leave the surface rough, or score it with a riffler, so as to render the hairy appearance of an animal's hide or the feathers of a bird. If you decide to polish a carving of this sort afterwards, do not forget to use a stiff bristled brush to force the abrasive between the lines of the hairs.

Soapstone (and alabaster) figures which get badly broken can often be retrieved by inlaying them (see the chapter on combination, *page 73*). Thus if you are carving a soapstone frog and gouge out the eyes too deeply, drill them out completely and inlay two eyes of cannel coal or jet. If you break an alabaster horse, after you have carved it, repair the break with a saddle and cinch made from lignite.

Fig. 7a. Animal marked out on soapstone block

Fig. 7b. Rough figure released from block by a series of straight sawcuts

Firing Soapstone

Steatite is a *natural ceramic material.* Instead of going through the laborious process of mixing clay, throwing on a wheel, and finishing, functional articles such as cups, bowls, plates and spoons can be carved directly in soapstone and then fired. This is done in India today, and it is just as possible to carry out here. The benefits of a designer being able to carve his own ceramic work, instead of handing it over to a potter to throw, are too obvious to require comment. Soapstone dishes can be placed directly onto a hot plate: they will also serve to keep food hot.

Because of its heat-retaining properties, soapstone is an ideal material for bath tubs, unlike some other stones, such as porphyry for example. There is a story told about an eighteenth-century nobleman who bought a magnificent porphyry sarcophagus in Italy, while on the Grand Tour, intending to use it as a bath tub. The minute he arrived home he ordered a bath. Five footmen obediently filled the tub with hot water brought in buckets, but when the great man dipped his toe into the bath he found it was too cold to be enjoyable. He indignantly discharged all five footmen. Not until he had sacked two other sets of five servants did he discover that it was the tub which was to blame, not his servants, for porphyry is such a cold stone that it very soon cools the hot water poured into it.

Art has virtually abandoned heating units with the passing of the tiled porcelain stove, so beloved of Dutch and German artists and sculptors, and the Victorian cast iron fireplace, fire dogs and fire back. Soapstone however would make a most attractive sculptural cladding for even the starkest modern heating appliance, and it would also serve admirably for the shelf placed over large central heating units. Firing can be done in a ceramic kiln, in an enamelling kiln, or even in a domestic oven, providing it rises to a temperature of about 500 degrees C. Test pieces which I had baked for fifteen minutes at 500, 600 and 700 degrees C. all showed some signs of petrification. That baked at 800 degrees C. was by far the hardest and whitest however.

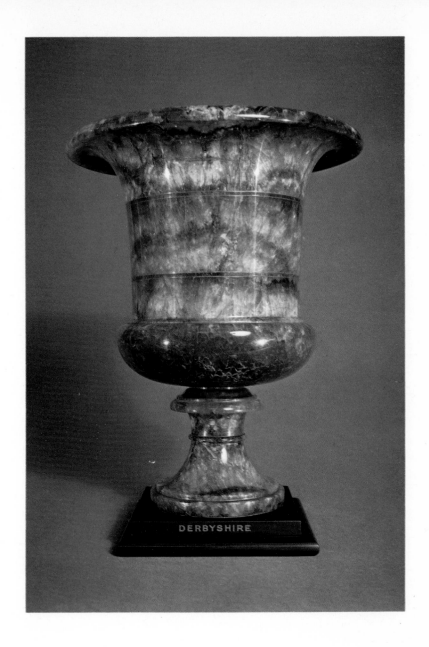

DERBYSHIRE

19th century vase of Blue John mined at Castleton, Derbyshire.

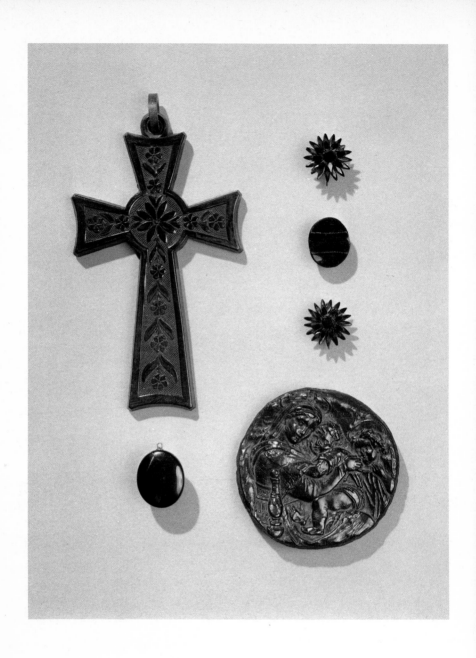

19th century Whitby jet. *Institute of Geological Studies.*

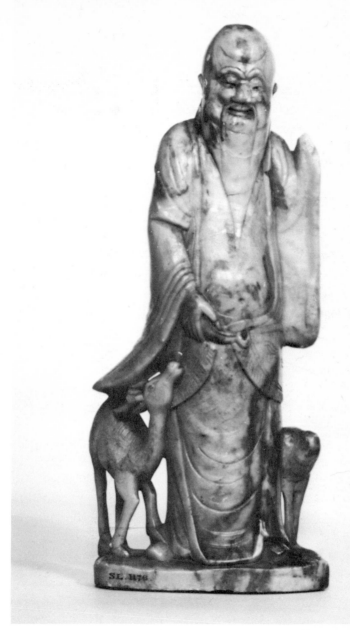

13. Chinese soapstone figure of Lao Tse. *Sir Hans Sloane collection, British Museum, London*

Nevertheless, it is possible to fire soapstone in a bonfire. The Indians have been doing this for centuries.

Wait till you have several pieces of soapstone to fire, and then put in an earthenware seedpan, covering them with another, and wiring the two together. Place the pans on two bricks which have been lain on their sides on the ground. Put wood and kindling underneath and around this improvised oven, light it and keep it stocked with fuel for at least six hours. Wait till the ashes are cool before you remove the soapstone.

By baking soapstone at graduated rising temperatures it can be petrified, either on the outside, part of the way through, or completely. In this petrified state (which resembles vitrification) soapstone becomes white and glassy with an enamel-like coating. This is due to a molecular rearrangement of the stone caused by the high temperature. The most striking change which it undergoes after being baked however is that, from being very soft, it becomes very hard. Specimens of soapstone which I had baked in an electric furnace became so hard that they rose from a hardness of 1 to between 5·5 and 6·5. Of course this remarkable property of soapstone has been known, empirically, for a long time, and it has even been used for sculptural purposes in the Indus Valley civilisations, such as Mohenjo Daro. Here stamp seals were carved in very intricate designs while the soapstone was soft. The seals were then fired and became just a little less hard than jade. Soapstone is also fired under brushwood bonfires in modern India to produce cooking pots, and is also used to make baths, stoves (such as one in the monastery of St. Bernard), to line furnaces, make gas mantles, and even for lamps and kettles for the Eskimos, who would have found it very difficult to do any cooking at all, or even have any heat in their snow huts, without this very versatile material. It was used by Viking craftsmen for moulds to cast silver jewellery in, for example. I shall try to suggest other uses to which it might be put; I am sure that the reader can think of many for himself.

Because soapstone can resist and transmit heat it can be used as a heated stamp to impress gold leaf onto leather, for the lettering process in bookbinding, or to make book marks ornamented with gold leaf or any other kind of ornamented leather. Hitherto there has

only been one expensive and time-consuming way of making these stamps, by carving them with a specially sharpened steel tool out of brass blanks. Now anyone who follows my instructions will be able to make up series of stamps, or alphabet letters, to whatever design he wants, for as few pence as he would have paid pounds for them in a craft shop. Soapstone stamps, once fired, will be just as hard as brass, last just as long if properly handled, will not require a special gas oven, and can be made so easily that it will be possible to produce a special alphabet, or set of stamps, for every specific piece of work.

Although raw soapstone will not stand a lot of weathering, and readily chips and scratches (as an examination of any Chinese soapstone figure will show) it can be carved soft and fired to a hardness that will withstand out-door weathering. Thus it now becomes possible for the first time for amateurs, or even children, to carve garden statuary, memorial plaques, house names, and so forth, have them fired in a ceramic oven, and set them up in place outdoors, confident that their work should last as long as the steatite objects recovered intact from Assyria, Babylonia, and other ancient civilisations.

Soapstone is extremely important to the enameller, because it needs no preparation, other than carving, before it can be enamelled and fired. The usual procedure for enamelling has been either to paint with enamel, or to prepare a copper base, which must be cast, rolled, sawn and filed, before being soldered with *cloisons* (if it is to be a *cloisonné* piece). Soapstone can be very readily carved and painted, or, if *cloisons* are desired, they can be cut directly into the material.

Further Projects in Soapstone

Intaglio carving

Now you can move from carving *bas reliefs* (*see Chapter V*) and carving in the round, to carving *intaglios*. Select a suitable block of soapstone, a few inches across, and saw it up with a hacksaw, so that it is square. Rub down the sides with sandpaper till they are absolutely smooth. To make the most of your cube, you should carve a seal on all six sides. In practice however, you will probably be content to carve just two faces. Choose a suitable design which embodies some single, striking feature, which would immediately catch the owner's eye, if this were a functional, and not just an artistic seal. You can have a small secondary design as well, so as to fill in the space.

Draw the design on the seal face with a pencil, and then cut down from the surface, using a wood engraver's veiner and chisel. Hollow out the intaglio—or scooped-out part of the carving—with wood

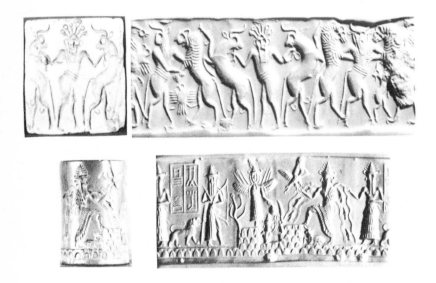

14. Assyrian and Sumerian cylinder seals showing impressions on the right. *British Museum, London*

engraver's gouges and chisels. Linoleum cutting tools and small craft knives are also useful here. As you proceed, take proofs on a piece of plasticine to see how the carving is progressing. When you feel it is as perfect as you can make it, polish the whole seal and then lay it aside for firing.

To accompany your intaglio seal, try making first a cylinder seal, and then a scarab. Cylinder seals made of steatite were used in the Indus Valley, in 2500 BC, and also in Assyria and Babylonia, to authenticate documents written on wet clay. They served the same purpose as a modern signature. The owner wore them on a ring, or a chain round his neck. When he wanted to lend authenticity to a document, he rolled the seal on the clay, so that it left an oblong design moulded on it (*see page 52*).

You can make a very large, impressive cylinder seal with a hole cutter, which is a set of tubular saws, with a drill in the middle. Only one size of saw is used at once, and the device can be held either in a twist drill or a power drill. Take a drill the same width as that in the centre of the hole cutter and drill a hole through a block of soapstone. Fit the smallest tubular saw into the hole cutter, place the end of the drill in the hole which has already been made and cut a tubular section through the block of soapstone. You will have to repeat the process from the opposite side of the block to get a sufficiently long cylinder. Both cuts from the tubular saw should meet exactly in the middle. Now saw off the top and bottom of the cylinder at right angles to the sides. Rub off the saw marks with sandpaper. The seal is now complete, except for the carving of the design in intaglio.

There should be no abrupt break in the figures carved on the cylinder. They should run round it continuously. So as to ensure this continuity, draw two parallel lines on a piece of tracing paper. The distance between the two lines should be the same as the height of the cylinder. Then draw a line from the top line to the bottom, at right angles to them. Make a pencil line above the edge of the cylinder seal. Place it opposite the vertical line, and roll it along between the parallels until the pencil mark on the cylinder comes to rest on the paper once more. Make another mark. The area of the seal's surface is now delimited on the paper. Draw your design on this oblong with pencil so that the design continues harmoniously right round the

cylinder. Now ink in the pencil lines with a mapping pen and indian ink. Cut out the pattern and paste it to the outside of the cylinder. When it is dry, cut through the outlines of the design with a sharp pointed craft knife, and then scoop out the intaglio relief. If you want to make the same project in one of the harder stones, you will have to file or grind the cylinder to shape. You may also find that an engraver's bit, working in a flexible drive, will help you to cut out the design.

Scarabs were made out of soapstone by the ancient Egyptians in the form of the sacred scarabaeus beetle. The men of Egypt had watched this beetle patiently rolling together a ball of clay, from which eventually a baby beetle would emerge. They thought the insect

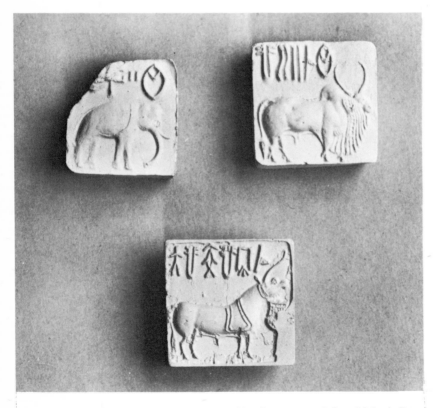

15. Soapstone seals from Mohenjo Daro.
Indus Valley civilisation, third millenium
BC. *British Museum, London*

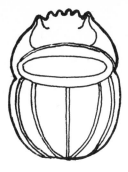

Fig. 8a. Scarab, *top*

Fig. 8b. Underside of scarab engraved with 'Ankh', the hieroglyph for 'Life'

was a god which could create life, though we know that it was merely laying its eggs in the clay balls. The underside of a scarab (*Fig. 8b*) bore either a simple spiral pattern or an inscription, usually the name of a deified Pharaoh. A hole was usually drilled through the long side of a scarab so that it could be worn on a swivel ring, the beetle side being worn outwards (*Fig. 8a*) except when the seal part was needed to impress on wet clay.

Take a soapstone offcut with a flat side, and draw the outline on the flat part. Cut round it with a piercing saw blade, which will give a good clean cut, then carve the top into the scarab shape. Polish the top of the scarab, then cut out the design of the seal. If you do not want to use a flexible drive, you can try holding an engraver's bit in a wooden peg handle. The soapstone scarab which you make will serve as a model for one to make later in some harder stone, such as malachite.

Fired soapstone makes an ideal seal for sealing wax. Don't forget to lick the matrix of the seal before you press it down on the hot wax. Sealing wax seals, being more likely to be used for sealing registered parcels than the large decorative ones we have been thinking about, should have a small personal design, about half an inch across, embodying your initials or some kind of personal mark. A sealing wax seal can be given an ornamental handle of some other soft stone, such as alabaster.

Line engraving on soapstone

Even easier that carving an intaglio, is making a line engraving for frottage. Although printing from the engraving once you have made it takes a little longer, this is such a satisfying medium that no time spent on it can ever be wasted. Select a suitable flat cut of soapstone, big enough to make a line engraving which can be framed and hung. Place the cut on a piece of carpet underlay spread on your bench and plane it completely smooth with a surform. Now scrape down any irregularities with a scraper such as an old craft knife blade or a razor blade glued between two pieces of cardboard. Now lay the face of what is to be the block on a piece of medium sandpaper laid on a flat surface and rub it smooth with a circular movement. Repeat the same process on a piece of fine sandpaper.

When the soapstone is completely smooth draw your design on it with a soft lead pencil or trace it with carbon paper. The design should be composed of fine lines (*see one suggestion in Fig. 9*), set reasonably far apart, so that they will show up white in strong contrast to the black surface of the frottage. Ink in the lines with indian ink and a mapping pen, and then take a wood engraver's veiner and make a delicate incision that goes about a millimetre below the surface. Press your left hand against your right so as to brake the progress of the veiner and prevent it going so fast it chips the sides of the line. When you have finished, the stone engraving should be well nigh invisible. The ink lines of the design will have disappeared, carved away by the veiner. Now is the time to take a proof. Squeeze out some printer's ink on a glass plate and roll it in two different directions with a rubber roller. Keep rolling until the consistency is right—you will only learn this by experience. Roll it onto the stone engraving. Take a piece of newsprint, or other thin paper, which has been damped by leaving it overnight interleaved between sheets of damp blotting paper or newspaper, and lay it on the engraving. Rub the paper down with a buren (a ball of cotton wool rolled up in calico will do for this). The incised lines of your engraving should now be standing out in white against a black background. (*Fig. 9a is lightly inked, 9b more heavily*).

Alternatively you can make a much more interesting and varied surface by dabbing on the ink with a dabber made of cotton rolled

Fig. 9a. Rubbing from engraved
soapstone block. Light ink

Fig. 9b. Rubbing from engraved
soapstone block. Heavy ink

round a ball of cotton wool. The print will pick up the irregular distribution of ink put on by the dabber, and also the weave of the fabric. You can vary the effects of a frottage by rubbing with a dry medium, such as Tiranti's cobbler's wax in black or gold, as though you were making a brass rubbing.

Where specks of dust have settled on the block they will show up as white marks. These can be an attractive addition to a print, but if you want to remove them, rub down the block with a rag soaked in paraffin. An old toothbrush dipped in paraffin will take out the ink from incised lines. Some few impressions will have to be pulled before you are satisfied that the proof is perfect. You may, for example, decide that some lines, which ought to be white, are black. Cut them deeper with a veiner.

Once you are past the proof stage it is time to think about printing an edition. Decide what number you want, twenty-five, fifty, or a hundred. Cut as many pieces of paper of the right size as you need and damp them before you use them. Interleave your pieces of paper between sheets of blotting paper, which you have damped by soaking every alternative sheet, keeping them overnight under a weight.

If you want to experiment further with line engraving on soapstone, ink the plate so that the ink is forced into the lines. Now wipe it clean with a rag. Place a piece of damped paper on the plate and rub it hard with a brush. The softened paper will be forced into the lines, where it will pick up the ink, giving a black on white engraving. It is worthwhile persevering with stone engravings in soapstone, if only

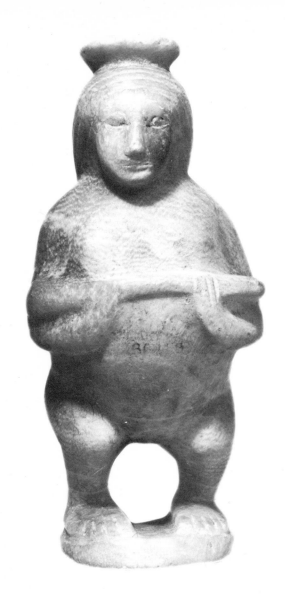

16. Alabaster vase, Ancient Egyptian,
later eighteenth dynasty, about 1300
BC. *British Museum, London*

Fig. 10 Chinese design for soapstone stamp seal. Character for 'Happiness'

Fig. 11 Soapstone engraving block for multiple repeat design. Traditional Chinese or Japanese

because 'petrography', the art of engraving pictures on standing stones, has now virtually abdicated to sculpture and lettering on stone.

Soapstone block prints

It is just a step from stone engraving to making stone block prints. You might decide to begin by making something quite small, such as the seals or decorative stamps which the Chinese and Japanese have been making from steatite for hundreds of years. A Chinese or Japanese artist usually had two seals, one containing his family name or artist's name, the other containing some classic aphorism, like *Tai Bi Fu Gen* (the truly beautiful is indescribable), which they would put on every picture they painted. Owners would also affix their seals to their pictures, in what seems to us a very philistine manner, but which seemed perfectly natural to the Chinese and Japanese. So a Chinese art collector would know his name would go down to posterity associated with some masterpiece he had once owned.* As artists and owners varied their seals from time to time, it was not out of the way for a painter to leave a chest containing five hundred seals, all of which he had used at one time or another, after his death. Seal carving became a very important branch of Chinese art, and special forms of the Chinese characters were even devised, just to be carved on seals (*see example in Fig. 10*).

* Like Tennyson's Ulysses, he was 'a part of all he had seen'.

The pigment for seals was a paste made of Diana Weed dried for three years, or soft, finely chopped rabbit hair boiled in castor oil for one hundred hours with white wax and then coloured red, brown, blue, or tea colour. I suggest you make your own variation of this seal pigment by mixing up ground colours, or Chinese black ink or cinnabar ink rubbed down on an ink stone, with a little almond oil, mixed with rabbit skin glue dissolved in hot water and mixed to an emulsion.

Choose as an opening design one of the Chinese bird or butterfly stamp silhouettes which I illustrated in *Fig. 11*. These are traditional and turn up again and again in all sorts of media, from lacquer to brocade, but they were obviously devised as stamp seals. Trace your design on thin layout paper. Paste it down on the smoothed face of a soapstone block, reversing it. Rub a little oil on the surface to make the paper more transparent, and cut right round the outline with a sharp knife, such as a wood engraver's knife or a craft knife. Trench up to this line with a wood engraver's chisel. When all the main parts of the stamp are standing up in relief, cut away the rough with a broader wood engraver's chisel or gouge. Small parts of the print inside larger areas which are intended to show up white, such as the eyes of animals or birds, can be picked out with the point of a wood engraver's knife. To print, make up a pad in an old tin containing the pigment. It will take you a little practice to get just the right consistency in which to apply it. If you want to you can use undiluted poster colour instead of ink. Small stamps of this sort can be combined to make Christmas cards, decorative designs, printed fabrics, and many other projects.

The soapstone printing block appears to have been successfully introduced to the Arctic Eskimos by the Canadian government who encouraged the Innuit craftsmen to produce prints of a very high quality. You can combine the instructions which I have given you for line engraving and stamp making to make a print of this sort. As it will be larger than the stamps you have made hitherto, hold the paper down on the block with a bulldog clip before you begin your rubbing. Never try to put a soapstone block in a press, it will almost certainly crack it. Always wipe down your blocks and stamps with paraffin-soaked rags and toothbrushes after you have used them. It is also a good idea to number each block on the back with enamel paint, and keep a

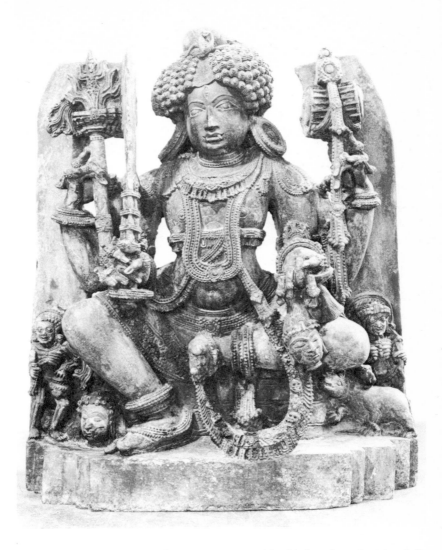

17. Mediaeval temple statue. India.
Soapstone. *British Museum, London*

Fig. 12 Designs for soapstone stamps for gold tooling book bindings

stock book in which there is a print from each block, with the accompanying number.

Gold stamping on leather

Of all the properties of soapstone, its ability to print gold designs on leather is surely one of the most remarkable. Hitherto, in order to do any gold tooling on leather, it was necessary to have a specially forged brass blank, set in a handle, which had to be cut with steel tools. The cost of making a soapstone gold tooling stamp is negligible, and it is so simple that it can easily be attempted by children in schools who want to make their own bookmarks or bindings.

Begin by cutting out a Tee-shaped blank from soapstone, big enough to take, on its widest face, the lettering or ornament which you intend to apply. Sandpaper the face of the blank smooth, and cut a wooden handle for it from a wooden batten or a piece of scrapwood. It should have a groove in it which will exactly fit the tongue of the soapstone blank. Push the tongue into the groove, hold the stamp and handle in a vice, and then drill two holes through the handle and blank combined. Fasten the blank into the handle with nuts and bolts. The gold tool is now ready to be engraved. Place the handle in a vice and carve it in that position.

The design for the tool, like that for the printing stamp discussed previously, will be drawn on a piece of thin layout paper, outlined in indian ink, and then stuck down, in reverse, on the soapstone face. I have illustrated some decorative stamps for tooling book ends, or the covers of books (*Fig. 12*). If you want to make up a ticket for the spine of a book which you have bound, giving the title and author, with perhaps the volume number as well, I think the best way to do this is to write what you want in decorative script on a small area, reverse it, and use this as the design for your stamp. There is no need to imitate printed letters. Soapstone gold tooling is a new medium and

should be treated as such. Obviously your designs must not be too large, they should be proportioned to the size of a book marker, which would normally be about nine inches long by one wide, about an inch and a half of the long side being the tasselled end.

Play for safety in designing your first gold stamps. Try a flower, or a leaf, something that can be repeated attractively, so that the whole pattern is made up from just one stamp. If you want a pictorial design, make a simple one, such as the silhouette of your favourite author. Charles Dickens has an unmistakable silhouette, which can easily be cut out. Skiver (split sheepskin), from which most book marks are made, takes an impression very easily, whether it is gold stamped, or 'blind tooled', that is, the hot tool is pressed onto the

18. Steatite bowl, representing Serapis, Isis and Harpocrates, Egyptian, Roman Period, first century AD. *British Museum London*

leather, either directly, or through a piece of paper. Use craft knives and wood engraver's chisels to cut away the parts of the soapstone outside the design so that the stamp stands up in bold relief. Take a proof by inking it and pressing it on a piece of paper. Now take an asbestos mat and put in on the burner of the gas stove under a low flame. Take an old tin can, cut both ends out of it, and rest it on the mat. Place the stamp upright in the tin so that the soapstone rests on the asbestos mat. Let the stamp become so hot that it will just hiss when placed on a wet sponge.

If you want to blind tool the leather, lay it down on some hard surface such as a drawing board, pinned down with paper strips and drawing pins, and press the tool down on it. It will impress the pattern of the stamp indelibly on the leather. If you want to blind tool a book, fasten it in a lying press.

For gold tooling, mix up some glaire. This is made from white of eggs beaten up with an equal quantity of vinegar. Make up a gold leaf cushion, a square leather pad rubbed with bath brick, and have ready an old kitchen knife, or a bookbinder's knife, also rubbed with bath brick, lying on the cushion. Put a book of gold leaf on the cushion, open it out, and place a leaf on the cushion with the knife, and paint the inside of the design with a little glaire laid on with a brush. Blind tool your pattern on the book marker or book and rub a little cotton wool, lightly greased with coconut oil, on the pattern. Now cut up the gold leaf to the size you require by sawing it with a knife, and pick up the cut piece by touching it gently with a flat pad of cotton wool lightly greased with coconut oil. Place it gently on the leather. It can be dabbed gently down into the lines of the blind tooled pattern. Place a thin transparent piece of paper on it (a transparent plastic will also do for this), and press the hot tool down so that it forces the gold leaf into the design.

Examine and brush in glaire into any parts of the design which have not held the gold. Re-tool with gold. Rub off excess gold with a slightly greasy rag.

No one who works in soapstone should ignore its moulding properties. It has been used to make jewellery moulds since Viking times. One enterprising Viking craftsman even made himself a soapstone mould which could make the crucifix and Thor's hammer with one

pouring, so that he could supply Christians and pagans alike!

I suggest that if you do any moulding, you use a metal with a lower fusibility than silver, such as lead, and that you take every precaution while pouring the hot metal, such as using a long-handled ladle, and wearing gloves, protective clothing, and a mask. To make a soapstone mould, select a suitably sized block for the object you want to mould and saw a double score right round it with a carpenter's saw. These scores will act as keys to make sure you have the two halves of the mould properly aligned and they will also help you to lash it together with wire before the metal is poured in. Now saw the block into two halves at its widest part. Cut a paper pattern the exact size of the inside of the block, draw on it the figure you intend to mould, and trace this figure on both sides, reversing the pattern so that you have a mirror image on the bottom half of the mould.

Scoop out both sides of the mould to the depth required for the figure, using wood engraver's tools such as gouges, chisels, and

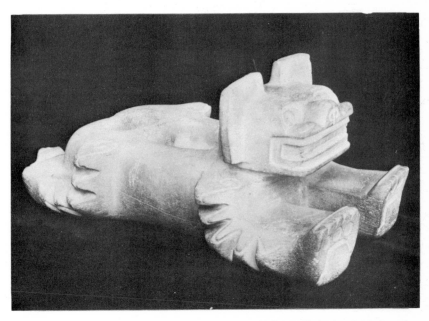

19. Onyx offering bowl. Mexico, about 600 AD. *British Museum, London*

65

knives. Gouge exhaust vents away from the arms and legs of the figure, so that they go outwards and upwards like a chimney in a house gable. These will carry away the hot gases as they escape from the mould. If you are casting in lead you can position the scooped out figure with outspread arms, and then bend his arms, or legs, into the correct position afterwards. This was the technique used by the craftsmen who made model soldiers as special orders for customers in Germany before World War Two. However they used soft slate and not soapstone for their moulds.

Before pouring, dust the inside of the mould lightly with french chalk (which is of course just powdered soapstone) applied with a brush, to prevent the metal sticking to it, and then fasten the two halves of the mould tightly together by twisting wire round the scored grooves. Now heat the lead to melting point in a ladle and pour it in. Wait till it is cold and then trim off the flashes made by the exhaust vents.

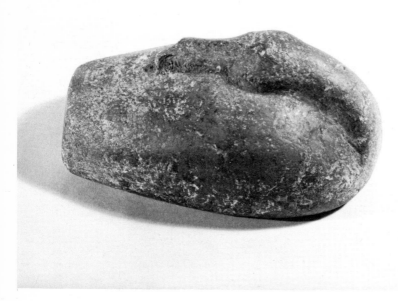

20. Weight in the form of a duck. Steatite. Ancient Egyptian. *British Museum, London*

Acquiring a Technique in Other Soft Materials

Although soap sculpture has been in existence at least since Victorian times, during its great hey day, the 1930's soap was not carved but modelled. Sculptors such as Lester Gaba were able to buy, in bulk, soft soap which could be shaped easily with a boxwood modelling tool. However the march of progress has abolished soft soap and replaced it with detergents. Accordingly, anyone who wants to make a beginning in soap sculpture has either to make his own soft soap by cutting down and mixing a hard soap bar with water, or, much better, he can simply do a direct carving on the bar.

Ordinary household soap in bar form can be easily roughed into shape with a piercing saw. Draw out the outline of the figure you wish to carve on the bottom of the bar, which usually does not have any lettering on it, and then cut round the outline. Cut another profile from on top. Scrape away the sharp angles with a craft knife. Put in the details with the point of the knife. Take a bone folder of the kind used by bookbinders and rub the figure all over with it to smooth it. You can use the point of the folder to get into folds of drapery and the like. If you are making an elaborate figure with detached legs and arms which are carved separately and have to be stuck on afterwards, pin them with lengths of copper pins such as those which are used by entomologists for setting butterflies. Do not forget these pins are there when you come to break up the figure afterwards. Alternatively you can stick two pieces of soap together with a solution of sodium silicate. This is not the sort of chemical you can buy across the counter of a chemist's shop and you may have to enlist the friendly aid of a science laboratory in some school or college to obtain it. A rub with a piece of tissue paper will enhance the gloss on the soap carving. Floss silk can be used as hair for soap busts, and they can be painted with poster colours.

You may well feel that you would like to keep permanently some of your soap work. One way of doing this is to make a cast from it. The most suitable subject for casting is an inscribed tablet. You can put this on a flat piece of soap, and then build a wall of thin strip wood

round the soap tablet before pouring plaster of paris over it. From this mould you can then cast a metal tablet in, say lead.

Wax is moulded more often than carved. It is however, possible to make highly satisfactory carvings from blocks of wax, particularly paraffin wax. These can be cut with craft knives and then if desired, coloured with oil colours.

Scarcely harder than wax to carve are the softest of the soft stones. Amber has a hardness of about 2 on the Mohs Scale. It can be easily carved with wood engraver's chisels, gouges and veiners. However amber is extremely brittle and if you are carving a subject which has fairly rounded outlines, it is safer to rough it out with a file and then gradually work in the detail with the point of a riffler. Give the carving a finishing down with very fine sandpaper, followed by flour pumice applied with a brush, followed in turn with whiting put on with a cotton cloth.

Jet, cannel coal, and lignite, though differing somewhat in consistency and appearance, can usefully be lumped together so far as working methods are concerned. They have all, at one time or

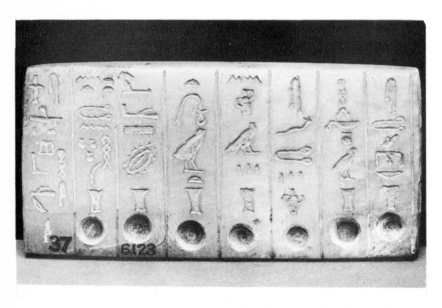

21. Alabaster tablet with seven holes for oil. Ancient Egyptian, sixth dynasty, about 2200 BC. *British Museum, London*

another, been worked interchangeably. The complaints made about the Spanish jet workers of the renaissance and the British carvers at Whitby, that their jewellery did not 'wear' were probably due to the fact that they had, perhaps unwittingly, substituted cannel coal, which is much softer and more brittle than hard jet, for the 'real Whitby article'. All three substances polish up to a brilliant blackness, and all are suitable for making really fine carvings. In carving jet, all that is necessary is to cut out the shape of the carving on the pebble with a piercing saw, and shape the subject with rifflers, wood engraver's tools, and sandpaper. Finish by polishing with the traditional Whitby polishes for jet: emery powder, powdered rottenstone, then crocus powder, all of which must be mixed with sweet oil. Powdered flour pumice may be substituted for rottenstone.

No difficulty should be experienced in polishing or carving jet, but cannel coal and lignite often bear strong marks of their woody origin in the shape of deep fissures and cracks running into the block along the lines of the rings of the original fossil tree. There was nothing that bronze age or renaissance craftsmen could do about these cracks, except discard the block. However it is possible to consolidate them quite easily by painting the block with a solution of shellac and methylated spirits, and then spraying it with fixative, which is just the same solution (made up with white shellac, however) in an aerosol bottle. Particularly bad blocks of lignite can be steeped in a solution of shellac for some time until they have absorbed as much of the hardening solution as will fill up the cracks sufficiently to let them be worked easily.

The hardener will make the lignite slightly more difficult to carve, but it will ensure that it does not split under the knife. Keep a bottle of fixative on the bench and as the carving progresses spray it on any parts that appear to require consolidating.

Kimmeridge shale is another soft stone which admits of being consolidated by shellac. Rings can be cut from it by means of a hole cutter fixed in an electric drill, and it can be polished with emery powder, then flour pumice, followed by either crocus powder or cerium oxide, or jeweller's rouge.

Clunch can be sawn roughly into shape with a carpenter's saw. It can be worked with stone cutter's tools, or by means of wood carving

tools. Do not try to carve too fine detail in clunch, shapes should be kept simple. It will not polish.*

Serpentine is the only decorative soft stone likely to be obtained in large enough blocks to admit of being carved with stone sculptor's tools. As it is such a comparatively soft stone it will admit of being worked with wood engraver's tools, or with wood chisels. Like all the semi-hard soft stones, serpentine requires a more drastic polishing treatment. Once it has been smoothed down, and all chisel marks removed with rifflers and abrasive blocks, it should be given an initial polish with a hard abrasive such as silicon carbide, coarse 80 grit,† then 220 grit should be applied, followed by fine 400, then by 600 grit. The final polish may now be appplied with putty powder (tin oxide).

Verdite, travertine, Cotham marble, fluorspar and other soft materials will react well to this series of polishes. As they all have a slightly different hardness some will require to be polished for a shorter time than others, and it may be possible to omit one of the series.

Caution is necessary in polishing malachite and turquoise, because, as I said earlier, they are very absorbent stones and can easily be ruined by having their colour spoiled through absorbing grease. Malachite can very easily split along the 'bands' of decoration which run through it. It is safer to work it with a file than saw it. Turquoise may seem too hard a material to be discussed in a book of this sort. It is however worked by the most primitive people, like the Eskimos and the Zuni Indians of the Pueblos, who drill holes in raw turquoise with a very simple twist drill mounted with a flint.

Turquoise, like the other materials described here, will admit of being sawn and worked up with a file and riffler.

Meerschaum will probably be devoted, during the rest of its existence as an artistic material, to carving pipes. Anyone who wants to carve a meerschaum pipe would do best to buy a ready make block pipe, with stem attached, from the Amboseli Merschaum Company, Arusha, Tanzania. These pipes offer a varying area of about three by two inches for carving. Merschaum can be easily whittled into shape

* But may be treated with a good proprietary hardener.
† These figures refer to the grades of the different abrasives and should be asked for by number.

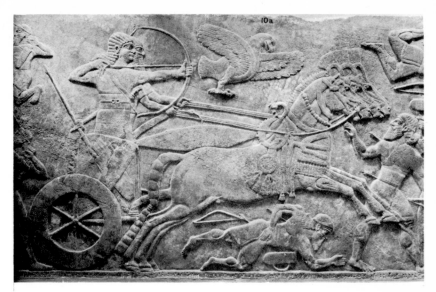

22. Assyrian bas relief of Ashurnasirpal II. Ninth century BC. An alabaster relief showing a scene of battle from Nimrud. *British Museum, London*

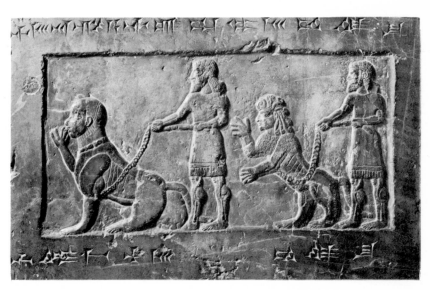

23. Black obelisk of Shahmaneser III. from Nimrud. Alabaster, Assyrian, eighth century BC. *British Museum, London*

Fig. 13 Traditional Chinese snuff bottle
shapes

with a craft knife, and finished with spills of sandpaper. Now that
merschaum blocks are submitted to a hardening process they are
much less likely to break than when raw merschaum was used.
Cheese curds dissolved in water-glass and mixed with powdered
calcined magnesia is the traditional recipe for merschaum cement.
However, probably just as good as cement, and a better filler, is
ground gum arabic, pounded with odd scraps of merschaum in a mor-
tar, and pressed into any cracks or crevices in the rough block. As the
smoker of a merschaum pipe will absorb any substances used in its
construction it is essential that these should be non-toxic. Merschaum
pipes can be polished by rubbing them over with wax polish and
polishing with a soft brush.

Projects in soft materials are likely to be limited, not by any sculp-
tural difficulties, but by the price of some of the more expensive
materials and the sizes in which they can be obtained. Thus you can
buy a turquoise for 25p, and malachite by the pound, at prices which
vary with the shop you go to, while amber is rather expensive and has
to be bought from Germany. I suggest therefore that the reader
makes his jewellery, or miniature sculpture, from the more expensive
materials—there is an annual exhibition held just for miniature sculp-
tors by the Royal Society of Miniature Artists at their new gallery in
the Mall, London. The less expensive materials, such as serpentine,
can be worked into busts, bas reliefs, inscribed plaques and other
sculptural forms.

72

Materials in Combination

There is no doubt that most of the materials described in this book look best in combination, so that their colours and surface markings stand out in marked contrast. In the past this combination was achieved in the grand manner, and the sculptures of masters of the Decorative Period of English sculpture in the late nineteenth century, such as Gilbert and Lynn Jenkins, produced vast panels where glowing bronze or silver gilt reflected the soft sheen of malachite or turquoise. I am not suggesting that we try to recapture the thrill of the Decorative Period, but instead work on a much smaller scale, yet still combine materials which are naturally harmonious.

One obvious vehicle for such work lies in the snuff bottle. This can be sawn or filed from suitably sized blocks in some of the shapes which I suggest in *Fig. 13,* and then provide with a cap of a contrasting colour, such as white satin spar alabaster on a jet bottle. If you want to, you can hollow out the inside of the bottle, and add an ivory spoon. There seems no doubt to my mind that most snuff bottles were made only for display. After all, one can only use one bottle at a time, and all snuff takers will probably agree with me when I suggest that the addict soon acquires a favourite container for his snuff, one which keeps it fresh longer than any of the others he owns.

Soft stone can also be sawn and shaped into fitted mosaics (*see Colour Chart on page 78*). A stone panel of contrasting colour serves as a background to the coloured insets, and the designs are let into it. This art, known as *pietra dura* or 'hard stone' reached its peak in baroque Italy and the stone carving workshops of India. A master pattern was drawn out on paper and transferred to the stone background, which was usually white or black marble. The parts of the panel which were to be inlaid with pieces of coloured stone were then scooped out with a chisel. Meanwhile designs of all the parts to be inlaid had been transferred to metal templates. The inlay pieces were then traced round the metal template, and ground to shape on a lapidary's wheel. In India the process of cementing the coloured inlays in place on their stone background was accomplished very simp-

ly. They were dropped into the recesses cut for them on top of a blob of sealing wax. A hot iron was then passed over the work, cementing the inlays in place.

Other craftsmen attempted the same kind of inlay, only in soft materials. The Pueblo Indians made very attractive pendants and ornaments of jet, inlaid with turquoise and bone.

All you need to carry out this technique is a piercing saw and a file. Concentrate to begin with on small-sized projects, such as the Pueblo Indian pendant which I have drawn for you in *Fig. 14*. Make the body of the pendant from lignite a quarter of an inch thick. Trace the design for it onto your block and go round it with chinese white. Cut out with a piercing saw. Now cut the holes for the inlay with a wood engraver's knife, chisels and gouges. Before you ensure that the fit will be absolutely flush, cut the inlay pieces themselves, using a hacksaw to slice up turquoise or azurite to pieces of a size suitable to be shaped to an exact fit with a file. When you have completed all the pieces of inlay, stick them down on a piece of wood with a drop of hot lapidary cement (beeswax and resin in combination) and polish them.

24. Assyrian bas relief from the palace of Nimrud, Tiglath Pileser III, eighth century BC. Alabaster. *British Museum, London*

Fig. 14 Pueblo Indian pendant of jet or
lignite, inset with turquoises

Smooth and polish the lignite pendant, making sure that you brush
out any traces of abrasive from the recesses before you finish. Offer
up the pieces of inlay in the recesses, laying a thread under each so
that it can be pulled out easily afterwards. Make sure that they fit, and
that they sink in until flush with the surface. Now put a dab of araldite
on the back of each inlay piece and press them into the recesses. If
there are any gaps between the inlay and the pendant fill them up with
powdered lignite mixed with araldite.

Stone marquetry is a natural extension from inlay designs. Here, in-
stead of parts of the stone being gouged out to allow inlays to be inset,
the background has the pattern to be inlayed sawn out with a piercing
saw. The inlays are then fitted into the resulting gaps, just like pieces
in a jigsaw puzzle.

Draw out the design for a piece of stone marquetry such as a sim-
ple brooch with a black dolphin in jet fitted into a ground of white
alabaster. Make the dolphin first and then trace round it on the
alabaster background, which should be as thin as you can make it,
say a quarter of an inch. Drill through two points in the area to be cut
out for the dolphin with a twist drill, insert the blade of a piercing saw,
and cut out the dolphin shape. Polish both sections separately and
then cement them together. Back the brooch with a support such as a
thin piece of copper, and mount.

The soft stones described in this book will give you a well stocked
palette for constructing green leaves (serpentine and verdite) dead
leaves (lignite smoothed but not polished) mottled colours to suggest
flowers or fruit (malachite and verdite) blue and yellow for butterflies
or flower petals (azurite and onyx marble). You might like to experi-
ment with flower pieces, such as white snowdrops of satin spar with

75

malachite leaves, against a dark background of Kimmeridge shale.

Maps are another excellent subject for stone marquetry. Don't forget, by the way, before you throw away any off-cuts of stone that looks rather unattractive or ordinary on the surface, that it may be one of the fluorescent soft stones. These include fluorite, calcite, sodalite, shale, and Blue John. Some of these are phosphorescent as well as fluorescent, and Victorian lapidaries were urged to ornament their bedroom stoves with studs of Blue John, which would give off light during the night when heated by the stove. The easiest way to make these minerals fluoresce in the dark, however, is to expose them to the light of an ultra violet bulb. These cost about six pounds but give a magnificent display. Anyone who wants to check on the approximate colour of fluorescent materials can observe them in the display in the Natural History Museum, South Kensington.

The next step after marquetry is mosaic. In this medium the stone inlays are simply laid side by side and are cemented onto a base, which need not be stone, with grouting cement (*Fig. 15*). The simplest and most functional mosaic which you can make is a chessboard. Cut out eighteen square slices of onyx marble of one colour, and eighteen of another (try using Peruvian, which is green with amber bandings, and Argentinian, which is a beautiful cream). Use a metal template to make sure that you have these squares absolutely rectangular. Polish the squares and offer them up on a wooden base, where the position for each has already been marked in pencil. Fasten the squares with grouting cement on the board. A thin band of copper makes an ideal edging for a board of this sort.

Pictorial mosaics can also be made up from small cubes cut from the materials described in this book.

Much work is being done at present in miniature sculpture made from different coloured stones, in which dark colours suggest hair, light ones flesh tints, and so on. This kind of sculpture is associated with the Russian court jeweller, Fabergé, who however, worked almost entirely in hard stones, which had to be cut on a lapidary's wheel. These figures look just as effective if they are made from soft materials.

In conclusion, let me beg the reader not to neglect the obvious. A seal made from soapstone will do its job just as well if it is given a

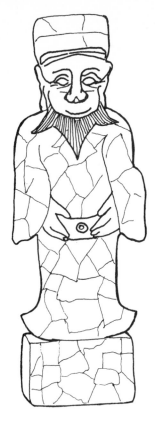

Fig. 15 Ming statuette in iron, coated with a mosaic or thin plates of realgar, a poisonous natural oxide of arsenic

handle of finely marked travertine, and it will be a much more decorative possession. The handle of a paperknife could be made from disks of lignite and satin spar alabaster cemented together alternately. A cigarette box made from soapstone might well be ornamented with roundels made from old turquoise beads, sawn in half.

77

A Palette of Soft Stones for Inlay

Amber	—	yellow, red, brown
Azurite	—	blue
Turquoise	—	blue
Lapis Lazuli	—	blue
Cannel coal	—	black
Jet	—	black
Serpentine	—	green
Malachite	—	green
Apatite	—	green
Amazonite	—	variegated green and white
Soapstone	—	pink, brown, white, mauve
Lignite	—	brown
Gypsum	—	white
Blue John	—	blue, but mottled in other colours

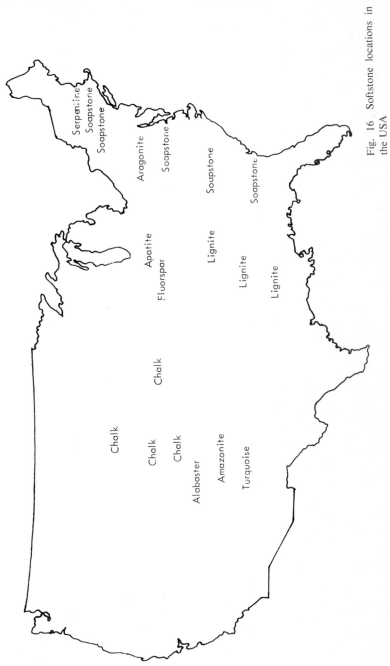

Fig. 16 Softstone locations in the USA

25. Mayan vase. Calcite. *British Museum, London*

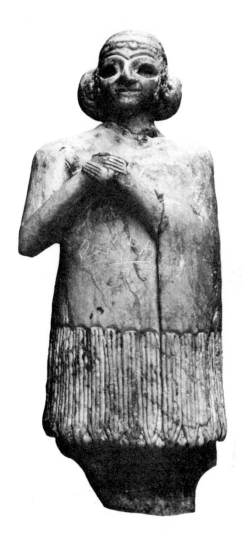

26. Sumerian statue, about 2500 BC.
Alabaster, originally inlaid with eyes which
may have been made from shell and lapis.
British Museum, London

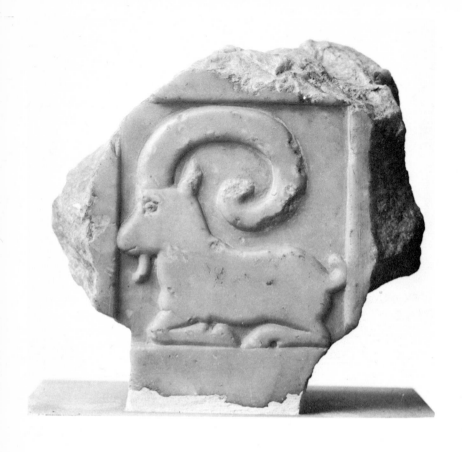

27. South Arabian alabaster carving of
the first millenium AD or later first
millenium BC. *British Museum, London*

28. Sumerian portrait statue of a man in the attitude of prayer, in alabaster, about 2500 BC. *British Museum, London*

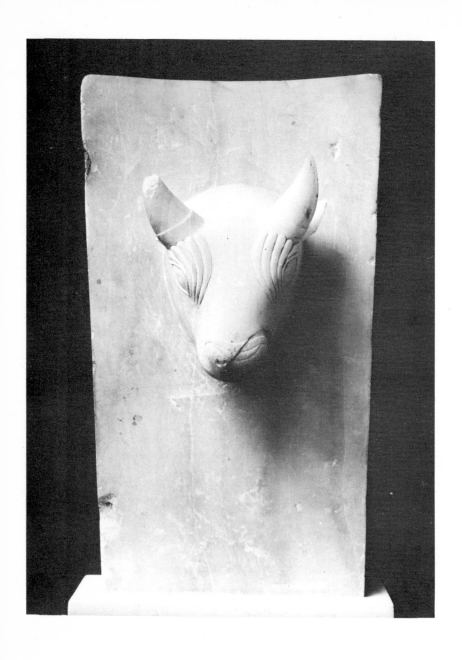

29. Grave Stela. Alabaster. South Arabian, later first millenium BC or early first millenium AD. *British Museum, London*

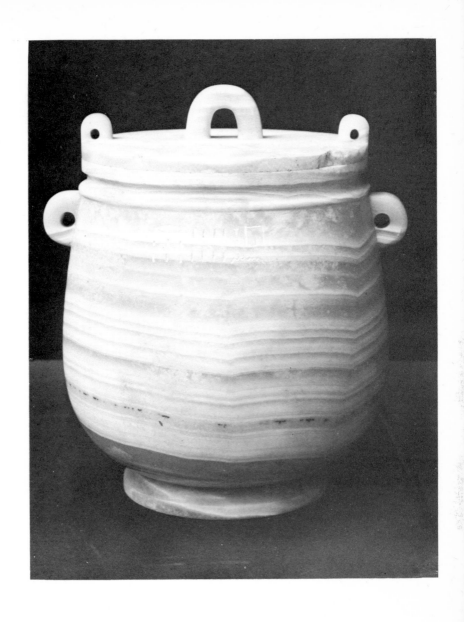

30. Alabaster jar, with lid. The inscription
says that its capacity is 'eight and a half hin'

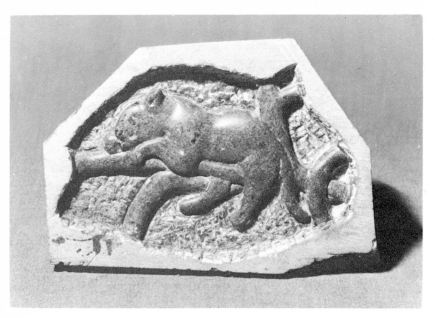

31. Modern amateur sculpture in soapstone. *Made by S. A. Hicks*

32. Nomoli figure in soapstone. These carvings are found in Sierra Leone and Guinea. Their date and purpose are merely conjectural. *Photo Mr. Swain, Curator of the Commonwealth Institute*

Addresses of Interest to Soft Stone Carvers

Suppliers of tools and equipment

Sculptor's tools, abrasives, cements, pigments etc.
Alec Tiranti, Charlotte Street, London W.1.

Stone
Suppliers in alphabetical order of Counties in the UK

Bedfordshire
Totternhoe Quarry, nr. Dunstable, LU6 2BU.

Essex
Chalk Farm Quarry, Newport.

Hampshire
Paulsgrove Quarry, Chalk Pit Road, Paulsgrove, nr. Portsmouth.
Tidbit Quarry, Martin, nr. Fordingbridge.

Hertfordshire
Springwell Lock Quarry, Rickmansworth.

Isle of Wight
Shorwell Chalk Pit, Shorwell

Kent
J. B. Martin (Crayford & Fawkham) Ltd., Pinden End Farm, nr. Dartford.

Lincolnshire
Kenwich Quarry, London Road, Louth Tetford Hill Quarry Horncastle.

Norfolk

Caistor Quarry, Caistor St., Edmunds, Norwich.

Mill Lane Quarry, Keswick, nr. Norwich.

Stiffkey Road Quarry, Wells-next-the-Sea.

Suffolk

Needham Chalks Ltd., Ipswich Road, Needham Market.

Wiltshire

Bemerton Quarry, Quidhampton, nr. Salisbury.

East Grimstead Quarry, nr. Salisbury.

Yorkshire

Queensgate Whiting Co. Ltd., Victoria Mills, Westwood, Beverley.

Middleton Whiting Co. Ltd., Middleton-on-the-Wolds, Driffield.

Bracken Quarry, Hornhill Works, nr. Lund, Driffield.

Hornhill Quarry, Hornhill Works, nr. Lund, Driffield.

Chalk

Suppliers in alphabetical order of Counties in the UK

Agricultural Contractors Ltd., Sarum Quarry, Whiteparish, nr. Salisbury, Wilts.

Allen & Boggis Ltd., Great Eastern Road, Sudbury, Suffolk.

Atlas Lime Works, Western Esplanade, Portslade, Brighton, Sussex.

Attlebridge Lime Co., The Station, Attlebridge, Norfolk.

Barker, A. East Common Lane, Scunthorpe, Lincs.

Barnet Lime Co. Ltd., South Mimms, Herts.

Barton Lime Co. Ltd., 91 Cadogan Lane, London SW1.

Chalk Liming Ltd., Church Lane, Claydon, Suffolk.

Challock Limeworks Ltd., Falcon Farm, Badlesmere, Faversham, Kent.

Cooper's Limeworks., Hinday Lane, Pinkneys Green, Maidenhead, Berks.

Corrals Ltd., 33 Kingston Crescent, Portsmouth.

Creaser, E. W., 20 Pavement, Pocklington, York.

Dorking Lime Co. Ltd., Bletchworth, Surrey.

Dunstable Valley Lime Works, Whipsnade Road, Dunstable, Beds.

Kilco Chemicals Ltd., 374 Shankhill Road, Belfast.

Suppliers of other materials
Gypsum

Bellrock Gypsum Industries Ltd., 200 Westminster Bridge Road, London SE1.

	Chellaston Brick Co. Ltd., Chilwell, Notts.
	Dunstan and Wrag, 459 Queen's Road, Sheffield, Yorks.
Fluorspar	Bainbridge, W., Park House, West Gate, Bishop Aukland, Co. Durham.
	Blanchland Flour Mines Ltd., 140 West George St., Glasgow.
	Broadhurst T., Lomas Cottages, Litton, Buxton, Derbyshire.
Serpentine	Bosustow, V. C., Church Cove, The Lizard, Cornwall.
Onyx marble, shale, cannel coal, lignite, etc. (also by post).	R. F. D. Parkinson & Co. Ltd., Doulting, Shepton Mallet, Somerset, England.
Kimmeridge Shale	R. F. D. Parkinson, Doulting, Shepton Mallet, Somerset, England.

List of American Suppliers

Sculptor's tools	Allcraft Tool and Supply Company 215 Park Avenue, Hicksville, New York 11801. NY USA.
General arts and crafts suppliers for stone carving	CCM Arts and Crafts Inc., 9520 Baltimore Avenue, College Park, Maryland 20740.
Semi-precious soft stones (e.g. amber and malachite)	Astro Minerals, 155 East 34th St., New York, NY USA. Gems Galore 1328 El Camino Real, Mt. View, Calif. 94040 USA.